Adobe®
Photoshop
CS4

PEARSON
Prentice
Hall

Harlow, England • London • New York • Boston • San Francisco • Toronto • Sydney • Singapore • Hong Kong
Tokyo • Seoul • Taipei • New Delhi • Cape Town • Madrid • Mexico City • Amsterdam • Munich • Paris • Milan

PEARSON EDUCATION LIMITED

Edinburgh Gate
Harlow CM20 2JE
Tel: +44 (0)1279 623623
Fax: +44 (0)1279 431059
Website: www.pearsoned.co.uk

First published in Great Britain in 2009

ISBN: 978-0-273-72350-9

British Library Cataloguing-in-Publication Data
A catalogue record for this book is available from the British Library

Library of Congress Cataloging-in-Publication Data
Benjamin, Lou.
 Photoshop CS4 in simple steps / Louis Benjamin.
 p. cm.
 ISBN 978-0-273-72350-9 (pbk.)
1. Photography–Digital techniques. 2. Computer graphics. 3. Adobe Photoshop. I.
Title.
 TR267.5.A3B45 2009
 006.6'96–dc22
 2009016855

10 9 8 7 6 5 4 3 2 1
13 12 11 10 09

Designed by pentacorbig, High Wycombe
Typeset in 11/14 pt ITC Stone Sans by 3
Printed by Ashford Colour Press Ltd., Gosport

The publisher's policy is to use paper manufactured from sustainable forests.

Adobe®

Photoshop
CS4

in Simple steps

Louis Benjamin

Use your computer with confidence

Get to grips with practical computing tasks with minimal time, fuss and bother.

In Simple Steps guides guarantee immediate results. They tell you everything you need to know on a specific application; from the most essential tasks to master, to every activity you'll want to accomplish, through to solving the most common problems you'll encounter.

Helpful features

To build your confidence and help you to get the most out of your computer, practical hints, tips and shortcuts feature on every page:

ALERT: Explains and provides practical solutions to the most commonly encountered problems

HOT TIP: Time and effort saving shortcuts

SEE ALSO: Points you to other related tasks and information

DID YOU KNOW?
Additional features to explore

WHAT DOES THIS MEAN?
Jargon and technical terms explained in plain English

Practical. Simple. Fast.

in Simple steps

Dedication:

To Denise, Mom, and Dad with deep love.

Acknowledgements:

Over the years since I first started using Photoshop, dozens of people have offered inspiration, tips, and feedback. This book would not have been possible without their contributions. Some of them are named below, but most are not. All of them have my gratitude.

The person who got my feet wet working with Photoshop was James Acevedo, who immediately got me thinking about its artistic potential. Important mentors and teachers at the International Center of Photography include H. Eugene Foster, Per Gylfe, Shauna Church, and Kathleen Anderson. I also have to acknowledge my students at ICP. They were the ones who really taught me how to teach real people how to use this powerful, complex, and sometimes confounding tool.

Thanks to Dr. Neil Salkind for making it rain. Thanks also to Steve Temblett, Katy Robinson, and Laura Blake for supporting this project and coaxing it through to completion. It was a brilliant collaboration.

Throughout the sometimes gruelling process of writing and revision, my lovely wife Denise provided life and sanity support. I couldn't have done it without her.

in Simple steps

Contents at a glance

Contents

Top 10 Photoshop CS4 Tips

1 Getting started with Photoshop CS4

2 Set up Adobe Bridge

3 Work with the Brush tool

4 Work with layers and groups

5 Erase, move, crop and undo

6 Work with type

7 View your document in different ways

8 Pre-edit in Camera Raw

12 Sharpening

13 Saving and exporting files from Photoshop and Adobe Bridge

14 Printing

Top 10 Photoshop CS4 Problems Solved

Top 10 Photoshop CS4 Tips

Tip 1: Set and save Photoshop colour settings

An important aspect of working with photographs is maintaining accurate colour. By setting a colour space and establishing policies on how to handle conflicting or missing colour information, you can be assured of accurate colour whether you are printing an image or preparing to post it on the Internet.

1 From the Edit menu, choose Color Settings.

2 From the Settings menu at the top of the dialogue box, choose North America Prepress 2. (This will change options in the menus below, and the Settings menu will now say Custom.)

3 In the Working Spaces section locate the Gray menu, and change it to Gray Gamma 2.2.

4 Click the Save button.

5 Enter a meaningful name, such as General Photo, in the Save As box. If you are using a copy of Adobe® Photoshop that is on a shared computer, it's a good idea to include your initials in the name of the preference set.

6 Click the Save button.

7 When the Color Settings Comment box appears, ignore it and click the OK button. Do not click the Cancel button or your settings will not be saved.

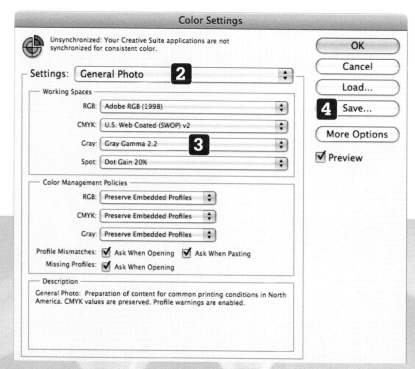

Tip 2: Set key preferences in Photoshop

History states control how many editing actions you can undo. The factory settings for Photoshop's brush tools and cursors are such that they'll be familiar to users who have been working with much earlier versions of Photoshop. We'll change these preferences to allow more flexibility in editing, and to make the brushes and cursors more informative and useful.

1 From the Photoshop menu select Preferences, Performance.

2 Click in the box labelled History States and change the value to 200.

3 In the column on the left side of the panel, click on Cursors.

4 In the Painting Cursors section, tick the box that reads Show Crosshair in Brush Tip.

5 In the Other Cursors section, click the button marked Precise.

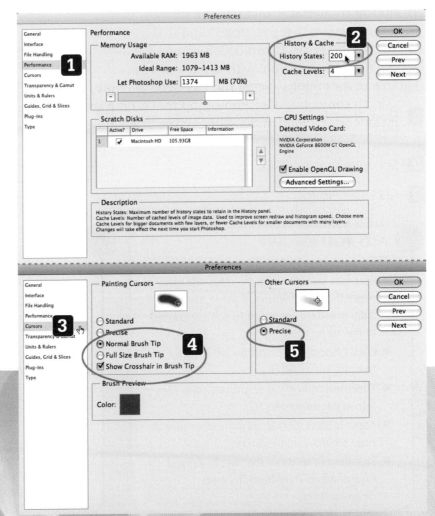

Tip 3: Download files from your camera

Adobe Bridge has a built-in tool called Adobe Photo Downloader, which allows you to copy files from your camera onto your computer's hard disk. Adobe Photo Downloader can even help you organise those images by performing such optional tasks as dividing them among separate folders based on the date they were shot.

Of course, there are several ways to get files into your computer from your camera. If you are already comfortable using another way, it's not imperative that you stop doing that and use Adobe Photo Downloader instead. However, it is a useful tool with some features that can make simple work of the process.

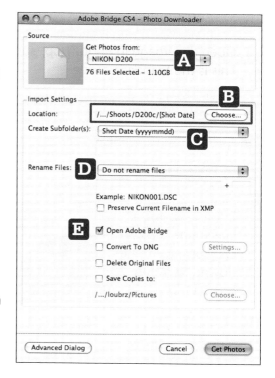

1 From the File menu, select Get Photos from Camera.

2 Set options as needed.

3 Click Get Photos.

? DID YOU KNOW?

These are some features you may need:

- Menu to select media (A). This will have more than one option, if you have more than one card attached to the computer at the same time.
- Click Choose ... to specify where your files will be saved (B).
- There are options to segregate your files into separate folders (C).
- There is an option to rename your files as they are downloaded (D).
- Tick this (E) to show the files in Adobe Bridge when they have finished downloading.

🔥 HOT TIP: While we refer to the process as getting files from your camera, it's actually not a great idea to connect the camera directly to the computer and download that way.

A better approach is to get a memory card reader that matches your camera's format (usually Compact Flash or SD, though there are others). You plug the card into the reader, and the reader into your computer. Downloading that way will be faster and won't drain your camera's batteries.

Tip 4: Switch screen modes

Whether you have a 15" screen or a display that is 30" or larger, working in Photoshop entails dealing with the available screen area. Photoshop has three screen modes that give increasingly more space to the image. In full-screen mode, even the menu bar goes away.

1 Open any image in Photoshop, and notice the arrangement of panels and menus. This is the Standard mode.

2 Hit the letter f key once, and the screen mode will switch to Full Screen With Menu Bar mode. Notice that the tabs disappear and the panels now float above the image.

3 Hit the letter f key again, and the screen mode will switch to Full Screen mode; the panels and menu bar disappear. Chances are the background is black, which is not a good colour to use when evaluating pictures.

4 If the background is black, hold down the control key and hold down the mouse button [right-click on the PC] on the background to display a menu.

5 Choose Gray from the menu.

6 Hit the letter f key again, and you return to Standard Screen mode.

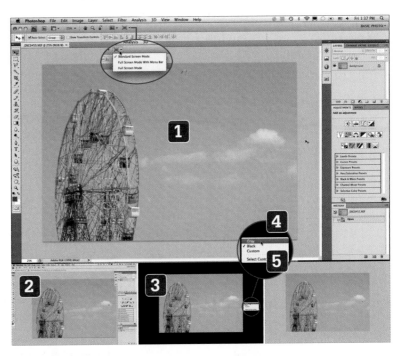

 HOT TIP: You can also switch screen modes via the menu in the top part of the Application Frame.

Tip 5: Black and white and colour in the same image

If you use a Black & White adjustment layer to convert your colour image to black and white, you can use the built-in layer mask to create a popular effect.

This works because of the way layer masks are designed: painting black into any part of the mask blocks the effect in that area. When you select an adjustment layer and paint in the image, any painting you do is applied to the layer mask.

1 Open a colour image and show the Adjustments panel.

2 Click on the Black & White layer icon to add a new adjustment layer.

3 Notice that the Black & White layer is selected.

4 Select the Brush tool from the Tools panel.

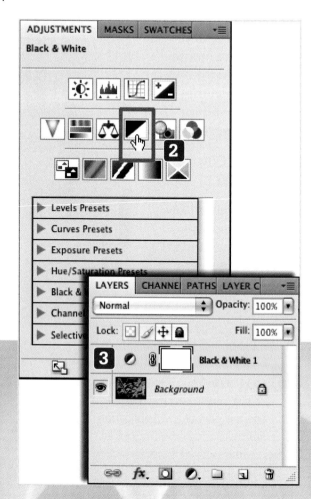

5 Set the foreground colour to black. You can tap the d key to set the default colours, and the x key to swap foreground and background colours as needed.

6 Use the Brush tool to paint with black in some parts of your image. You can use a low opacity soft brush to build up the effect gradually, if you like. The colour will show through in the areas that you black out.

7 Notice that the mask thumbnail contains black marks that reflect your painting.

8 Tap the x key to make your brush white, and paint over some of the area that you blacked out.

9 Notice that the black and white effect is restored to the areas you painted white.

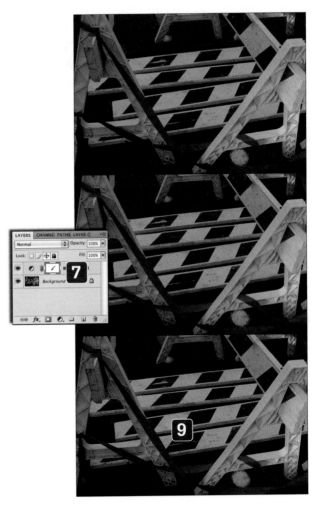

 HOT TIP: You can use any of the selection tools and techniques to make a selection and then fill the selected area of the mask with black. For example, you can use a Marquee tool or the Polygonal Lasso to make a selection, then use Edit, Fill to fill and select black for the colour.

? DID YOU KNOW?

Just remember that the black part of the mask blocks the effect of an adjustment layer. Any part of the mask that is white applies the effect 100%, and any shade of grey will partially block the effect.

Tip 6: Use the History panel

As you work in Photoshop, each action that you take is tracked, and the most recent actions are displayed in the History panel. How many appear there depends upon the History States preference you set in Chapter 1. The panel is a super-undo allowing you to step backwards through your edits to reverse a problem.

1 Click on the text or the icon on any row in the History panel list to move to a different history state. You can move forwards or backwards in the history.

2 Do not click in the boxes along the left edge of the History panel list. Clicking there loads the History Brush; it does not change the history state.

3 If the list of states is sufficiently long, the scroll bar will be active. Use the scroll bar to navigate between the history states in the list.

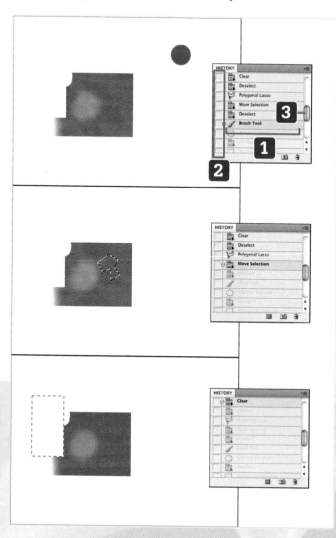

HOT TIP: History states are lost when you close the file.

? DID YOU KNOW?
Two advanced features that you might want to explore on your own are History Snapshots and the History Brush.

Tip 7: Soften wrinkles

Retouching varies a lot and is a matter of personal taste. Some people insist on having all of their wrinkles removed, but that often produces a very unnatural look. An alternative is to use the Healing Brush and Clone Stamp on a blank layer to create a smoothed-out version of someone's skin, and then fade the retouching a bit to restore some of the original texture beneath. The result is a more believable look.

1 In the Layers panel, click the Add a New Layer button, and rename the layer retouch.

2 In the Tools panel, select the Healing Brush.

3 In the Tool Options panel, set the Healing Brush to Mode: Normal, Source: Sampled, and Sample: Current & Below.

4 Click on the retouch layer to select it, and completely heal the lines that you want to lessen.

5 The result will be a face that looks unreal.

6 Fade the opacity of the retouch layer until some of the lines return in a subdued way.

> ▶ **SEE ALSO:** For detailed information on using the Healing Brush, see Chapter 9.

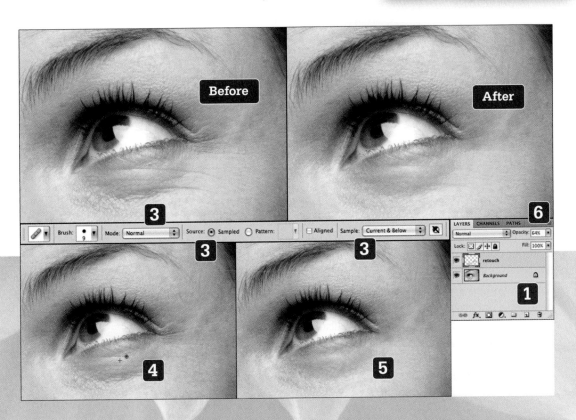

Tip 8: Use File Info to embed your copyright

The File Info system allows you to embed metadata into your image. Metadata is a broad term for descriptive data. The File Info system has exactly the same interface in both Adobe Bridge and Photoshop. Anything that you enter into your file in Bridge will be there when you open File info in Photoshop.

1 Select File, File Info ... from the menu. The File Info dialogue will appear.

2 Fill in the dialogue as needed.

3 Click OK.

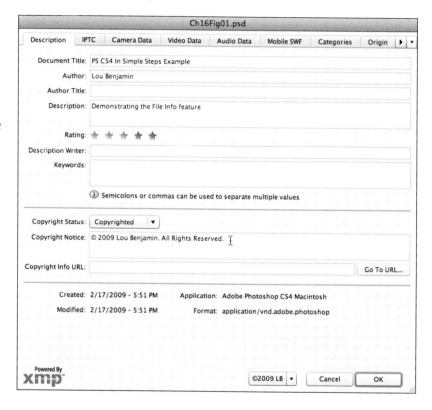

HOT TIP: Technically, the proper way to write a copyright notice is to either spell out the word or use the symbol, which is a c inside a circle ©. (c) is not actually recognised as a proper copyright symbol. On the Mac, the keystroke for the copyright symbol is Option + g [Alt + 0169 on the PC]. You can embed a lot of information into your image files beyond your copyright notice. If you tag or keyword your images in Bridge, that information will also appear when you open them in Photoshop. This info is also embedded into any JPEG or TIFF files you export, making the images identifiable by search engines, including Apple's Spotlight.

Tip 9: Process batches from Adobe Bridge with Image Processor

When you call up Image Processor from Bridge, you're actually passing off the selected files to Photoshop for processing. The tool is the same; the main difference is that Bridge allows you to select specific files to process, rather than having to process an entire folder.

1 Select some images in the Content panel in Bridge. To select discontiguously, click the first image that you want, then hold down the Command key [Ctrl on the PC] and click on the rest.

2 Select Tools, Photoshop, Image Processor … from the menu bar. The Image Processor dialogue will appear.

3 Note that if you are processing RAW files, you have the option to open the first image to establish your settings, and have those settings apply to all subsequent images. This feature is also available when you run Image Processor from Photoshop.

4 Note that Section 2 has a Select Folder option that works the same as in the previous example.

5 Set all additional options to your liking. They work the same as in the previous example.

6 Press the Run button to process.

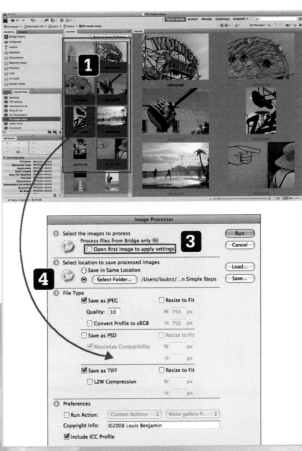

HOT TIP: In Mac OS X the blue button in a dialogue box is the default button. You can select it by hitting the Return key.

Tip 10: Make a PDF using Adobe Bridge

Adobe Bridge makes simple work of selecting a group of images and combining them into a PDF file. The PDF can even be set so that upon opening, it expands to full screen mode, and plays the images as a slideshow.

1 Using Favorites, Folders or Collections, browse a group of images in Adobe Bridge.

2 Change the workspace to Output, by using either the workspace menu or a workspace button. The Output panel will appear.

3 Select one or more of the thumbnails in the Content panel. Only the selected thumbnails will be placed into your PDF file.

4 In the Output panel, click the PDF icon.

5 If the Document section is collapsed, click the triangle next to the word Document to expand the section.

6 Specify the paper size, orientation, image quality and background colour in the Document section of the Output panel.

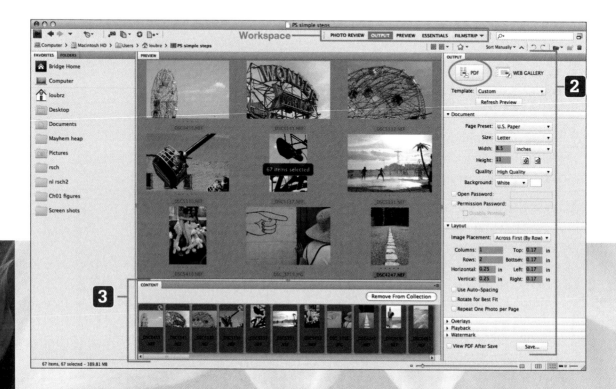

7 If the Layout section is collapsed, click the triangle next to the word Layout to expand the section.

8 Use the controls in the Layout section of the panel to specify how images will be arranged inside the PDF document.

9 Optional: if you want to review the PDF as soon as you save it, make sure that the box marked View PDF After Save is ticked. Use the triangle next to the word Playback to show the playback options and make the PDF automatically play a slide show when it is opened.

10 Click the button marked Save A Save As dialogue will appear.

11 Use the controls in the Save As dialogue to name your PDF and specify where it will be saved.

12 Click Save.

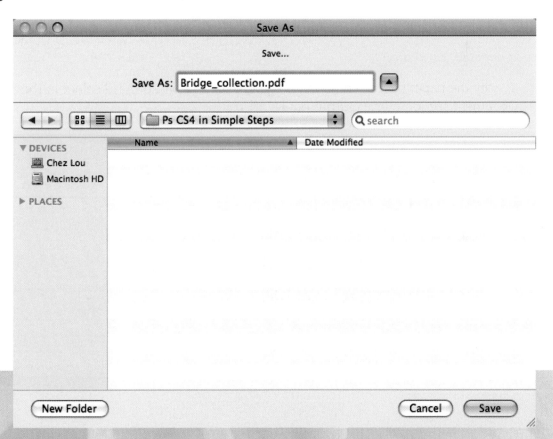

1 Getting started with Photoshop CS4

Introduction

Before we actually get to the task of working on our images in Photoshop, it is useful to set up the working environment so that it is best suited for the tasks we are most likely to do. Adobe Photoshop is a big application, designed to suit a number of different types of user, including photographers, graphic designers, pre-press specialists and others. We're going to optimise it for photographic work.

In this chapter, we're going to set up the working environment not only for Photoshop but also for Adobe Bridge, a companion file browsing tool. Adobe Bridge allows you to preview, organise and annotate files, and then open them in Photoshop and other Adobe Creative Suite applications. It also has a handy utility to download images from your camera.

Out of the box, there are some tools among the Photoshop panels that are useless for photographic work. Another set of tools will rarely be used, while a core set of panels is used all the time. We'll arrange Photoshop's panels to better match your uses, and to use as little screen real estate as possible; then we'll save that arrangement so that it can easily be recalled when needed.

Set key preferences in Photoshop

History states control how many editing actions you can undo. The factory settings for Photoshop's brush tools and cursors are such that they'll be familiar to users who have been working with much earlier versions of Photoshop. We'll change these preferences to allow more flexibility in editing, and to make the brushes and cursors more informative and useful.

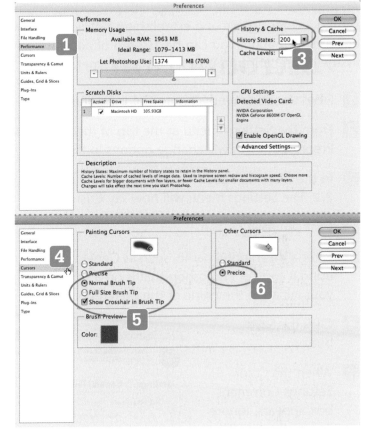

1 From the Photoshop menu select Preferences, Performance …

2 Click in the box labelled History States.

3 Change the value to 200.

4 In the column on the left side of the panel, click on Cursors.

5 In the Painting Cursors section, check the box that reads Show Crosshair in Brush Tip.

6 In the Other Cursors section, click the button marked Precise.

Set and save Photoshop colour settings

An important aspect of working with photographs is maintaining accurate colour. By setting a colour space and establishing policies on how to handle conflicting or missing colour information, you can be assured of accurate colour whether you are printing an image or preparing to post it on the Internet.

1 From the Edit menu, choose Color Settings ...

2 From the Settings menu at the top of the dialogue box, choose North America Prepress 2. (This will change options in the menus below.)

3 In the Working Spaces section locate the Gray menu, and change it to Gray Gamma 2.2. The Settings menu will now say Custom.

4 Click the Save button.

5 Enter a meaningful name, such as General Photo, in the Save As box. If you are using a copy of Photoshop that is on a shared computer, it is a good idea to include your initials in the name of the preference set.

6 Click the Save button.

7 When the Color Settings Comment box appears, ignore it and click the OK button. Do not click the Cancel button, or your settings will not be saved.

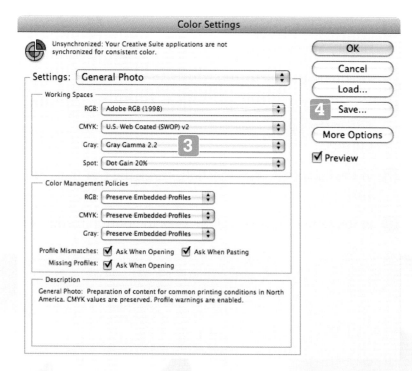

WHAT DOES THIS MEAN?

Digital colour is a descendant of the old paint-by-numbers system. A digital photograph is divided up into a mosaic grid of coloured dots called pixels. Each pixel is assigned a numerical value representing the colour and tone it contains. This is where things get interesting.

Each device that presents or captures colour, whether it is a digital camera, monitor, ink-jet printer with a particular combination of ink and paper, or digital projector, has a different range of colours it is capable of showing. That range of colours is referred to as its colour gamut. The various colour spaces we see (e.g. sRGB and Adobe RGB) can be summed up in a kind of map called a colour profile, which the computer uses to associate colour in the real world with the numerical values that each device uses to represent that colour. What's important to know about this is that a specific shade of green in the real world, for example, would have different colour numbers in Adobe RGB than it would in sRGB.

When we view digital images in Photoshop, the colours we see will be accurate as long as the photo has a proper colour profile attached to it. Photoshop's colour management is even able to translate between colour spaces, preserving the intended colour, assuming both spaces are actually capable of displaying the intended colour.

Use the Application Frame

The Application Frame is a new feature in Photoshop CS4. It is particularly useful if you work with multiple monitors, because the frame contains the tool palette, the tool options bar and the editing panels. This makes easy work of moving all of your tools and documents between monitors. For this book, it has the advantage of keeping our illustrations tidy, consistent and easier to follow.

1 In the Window menu, check to see whether Application Frame has a tick next to it.

2 If Application Frame is not ticked, select it from the Window menu.

3 The Workspace Switcher menu appears in the right corner of the Application bar at the top of the frame: hold down the mouse button to show the menu, and select Essentials.

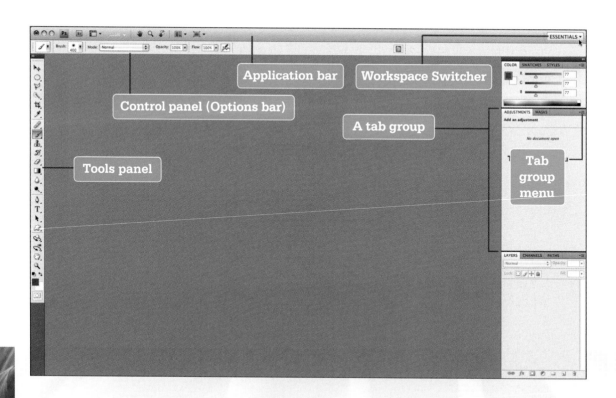

Close an entire tab group

Photoshop's panels can be grouped into sets of tabs, making a number of handy tools easily accessible without cluttering the screen. The Color, Swatches and Styles panels are for graphic design tasks. We'll close the tab group, freeing up space in the panel dock.

1 Locate the Color, Swatches and Styles panel set. If you just selected Essentials from the workspace menu in the application frame, the set appears at the top of the panel dock on the right side of the application frame.

2 A menu icon (a downward-pointing triangle with four horizontal lines next to it) appears at the extreme right of the tabs. Press and hold the mouse button down on the icon. A menu will appear.

3 Choose Close Tab Group from the menu

HOT TIP: All of the panels that appear in the dock are always available via the Window menu. If you accidentally close a tab group, or any single tab from a group, you can always get it back by selecting it from the Window menu. In other words, if you want Color, Swatches and Styles back after you close them, select any one of the three tabs from the Windows menu, and the group will reappear.

Rearrange tab groups

Groups of tabs can be dragged to a new location as needed. We're going to place the Layers, Channels and Paths tab set above the Adjustments and Masks set.

1 Position the cursor in the grey area between the Paths tab and the menu icon for the Layers, Channels and Paths tab set.

2 Press and hold down the mouse button, then continue to hold down the mouse button and drag the group upwards.

3 When the tip of the cursor touches the area just above the Adjustments and Masks tab set, a horizontal blue line will appear. Release the mouse button, and the tab sets will exchange places.

? DID YOU KNOW?

You can also combine tab sets by dragging one set into another. When you drag one set of tabs on to another, a blue rectangle will surround the entire tab set when the cursor touches the set. If you release the mouse button then, the two tab sets will be combined.

Move a panel into a tab set

One feature that will come in handy in future editing sessions is the Layer Comps panel. By default, it isn't visible. We'll make it visible, and put it into the Adjustments and Masks tab set.

1 From the Window menu, select Layer Comps. A tab set containing Layer Comps and Notes will appear in the left margin of the panel dock.

2 Press and hold down the mouse button on the Layer Comps tab. Continue to hold down the mouse button and drag the Layer Comps tab to the Adjustments and Masks tab set.

3 When the cursor lands inside the Adjustments and Masks tab set, a blue rectangle will surround the set. Release the mouse button, and the Layer Comps tab will snap into the set.

4 Locate the menu icon to the right of the Notes tab. Press and hold down the mouse button. A menu will appear.

5 Choose Close from the menu.

Show the Navigator, Histogram and Info tab set

These three panels will be useful as you zoom in and out of an image, make tonal adjustments, and assess colour and other attributes of your image. We won't use these panels as frequently as the panels we've added so far, so we'll keep them in the compact Button Dock that appears along the left edge of the palette dock.

1 From the Window menu, select Navigator. The set will appear in the Button Dock, with the navigator panel showing.

2 Click the button with the ship's wheel icon (the Navigator button) to collapse the tab set.

Add the History and Actions panels to the Button Dock

We'll add these panels and position them below the Navigator, Histogram and Info group.

1 From the Window menu, choose History. The button group will appear in the Button Dock.

2 Click the History button to close the tab group.

3 Locate the dashed double line at the top of the button group immediately above the History button.

4 Press and hold down the mouse button on the dashed double line, and then drag the group downwards.

5 When the tip of the cursor passes below the Navigator, Histogram and Info tab group, a horizontal blue line will appear. Release the mouse button, and the History and Actions buttons will snap into place.

Save your custom workspace

We'll assign a name to this arrangement of panels and save it. In that way, we can open and close panels at will, and then restore this arrangement by simply choosing it from a menu. You can create and save additional groupings of panels as you see fit.

1 From the Window menu, select Workspace, Save Workspace ...

2 The Save Workspace dialogue box will appear. Enter the name of your choosing.

3 In the box labelled Capture, be sure that Panel Locations is ticked. Leave Keyboard Shortcuts or Menus unticked, since we have not altered any of those settings.

4 Click the Save button.

5 Note that the name of your saved workspace now appears in the Workspace Switcher.

 HOT TIP: The panels in Photoshop are designed to take up a modest amount of space on the screen, so that you can see more of the image you're working on. Depending on how you work, you may want to expand those panels, make them even more compact, or temporarily make them disappear altogether.

- A dark grey bar appears at the top of the Palette Dock. Two sets of double triangles appear in it. Click the double triangles to expand or contract the panel displays. When contracted, the panels will be displayed as compact buttons. When expanded, the panels appear in tabbed sets.
- If you place the tip of your cursor precisely along the left edge of either the Button Dock or the main Palette Dock, you will see the cursor turn into a double-ended arrow. Hold down the mouse button and drag to the left or right to expand or contract that dock.
- A similar double triangle appears at the top of the Tools panel. Clicking it switches the Tools panel between a tall single column of buttons and a shorter double column.
- When you hit the Tab key, it will temporarily hide all of the panels, giving you an unobstructed view of your image. To bring the panels back, just hit the Tab key again.

Use a saved workspace

There are two ways to use a workspace that you've saved:

- Pull down the Window menu, and select Workspace>. The name of the workspace you created will appear at the top of the menu that appears. Select your custom workspace from the menu.
- Press and hold down the mouse button on the name of the workspace in the upper right corner of the Application Frame. A menu will appear, showing available workspaces. Select your custom workspace from the list. It will be near the top.

 HOT TIP: This feature is particularly useful in situations such as schools, where a number of people are sharing a computer. Each user can configure Photoshop's panels as they see fit, and save that workspace with their name on it.

Delete a saved workspace

You can't delete the active workspace, so we'll choose a standard workspace, and then delete the workspace that we don't need. If the workspace you want to delete is not active, you don't need to select a different workspace first.

1 From the Window menu, choose Workspace, Essentials.

2 From the Window menu, choose Workspace, Delete Workspace...

3 When the Delete Workspace dialogue box appears, use the menu to choose the name of the workspace you want to remove.

4 Click the Delete button.

5 A confirmation will appear asking whether you want to delete the workspace. Click the Yes button. The workspace will be removed from the Window, Workspace menu.

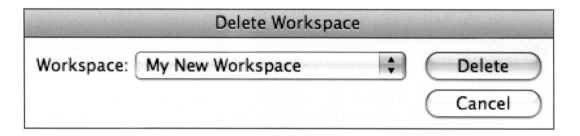

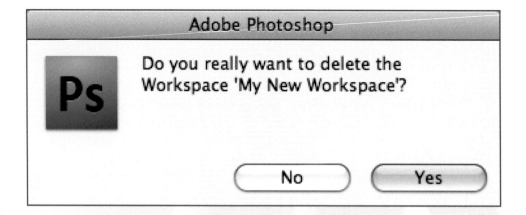

WHAT DOES THIS MEAN?

Modifier keys:

- Command key [Control in the PC]: this key is used to access menu commands (e.g. Command-z is Undo).
- Control + click [right-click in the PC]: using this combination on many objects in Photoshop brings up a contextual menu.
- Shift + click: either selects more items or constrains movement, e.g. click on a layer, and Shift-click to select more layers. You can also hold down the Shift key to make the Brush tool follow a straight path, or make perfect circles and squares with the Marquee tool.

Useful keystrokes:

- The bracket keys: a handy shortcut to change the size of the brush in most brush-based tools. The [key makes the brush smaller, and the] key makes it larger.
- Return key: when you enter values into a field, such as a size box in the Options bar, you can hit the Return key to commit the change. Otherwise, Photoshop thinks you still want to enter values into the box. Return also dismisses the drop-down dialogues such as the Brush picker that appears in the Options bar when the Brush tool is active.
- Enter key: if you're working with text boxes, Return inserts a new line, but Enter will commit the text changes. In most other cases, Return and Enter do the same thing.

Keystrokes that trigger modes:

- Option key [Alt in the PC]: holding down this key switches the current tool to its secondary mode, e.g. with the Clone Stamp tool active, Option-clicking an area tells Photoshop the area that you want to sample.
- Command [Ctrl in the PC]: with most of the tools in Photoshop, holding down the Command key temporarily converts it to the move tool. This is potentially a problem when using the painting tools on a layer, because you can accidentally move the layer out of alignment with other layers in your file.
- Q key: toggles Quick Mask mode on and off. Quick mask can be a useful tool for creating and modifying selections. If you accidentally fall into it, it can be confusing.
- Backslash key: if you click on a layer that has a mask, such as a Curves adjustment, you can see the mask as a colour overlay by hitting the \ key. To turn off the effect, hit the key a second time.
- Caps Lock: tells Photoshop to display all tools as precise cursors. If your paintbrush has mysteriously turned into a tiny crosshair without the outer circle, chances are your Caps Lock is on.
- Tab key: temporarily hides the panels in Photoshop, and switches most views in Adobe Bridge to the content panel (thumbnails) only. Hitting the key a second time returns to the normal view.

2 Set up Adobe Bridge

Introduction

Adobe® Bridge is a companion application for Photoshop and all of the Creative Suite applications. It allows you to browse, search for, preview, annotate and organise files; from there, you can open them in Photoshop or other applications. Adobe Bridge can also be used to create Web galleries and PDF documents. In this chapter we'll set it up to handle basic browsing and reviewing tasks.

Rather than get bogged down in the more sophisticated features of Adobe Bridge (of which there are many), we will deal only with the matters of locating and previewing files in Adobe Bridge, and then opening them in Photoshop or Adobe® Camera Raw. Once you're more versed in working with Photoshop, you may want to look further into what you can do with Adobe Bridge.

Launch Adobe Bridge from Photoshop

There is a Launch Bridge button on the left side of the Application bar, immediately to the right of Photoshop's Ps logo. When you move the mouse pointer over it, the button will turn into a red square with black lettering.

1 Click the Launch Bridge button. If Adobe Bridge is already running, its window will appear quickly; otherwise, you may experience a short wait while it starts up.

Arrange panels in Adobe Bridge

When you first launch Adobe Bridge, you will be presented with an array of panels that can be almost overwhelming. This grouping is less than optimal for our purposes, but these panels can be tamed.

As in Photoshop, we can rearrange and hide panels in Adobe Bridge, and these arrangements can be saved as named workspaces. While we had a fair amount of work to do to get a more optimal panel arrangement in Photoshop, one of the standard predefined workspaces in Adobe Bridge will suit our purposes very well.

The figure shows the key elements of the default workspace in Adobe Bridge. Even though we will be rearranging and hiding some of the panels in Adobe Bridge, the overall structure of the window will remain the same.

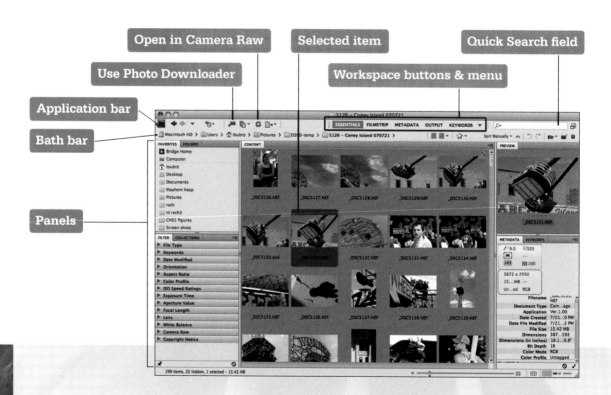

Set the Preview layout as your main layout

1 Locate the downward-pointing triangle at the right side of the Workspace buttons menu and hold down the mouse button. A menu will appear.

2 Choose Preview. The layout will change.

3 Position your cursor over the left-most of the workspace buttons (this is likely to be Essentials), then Control click [right-click on the PC] on the button to reveal a menu.

4 Choose Preview from the menu. The Preview button will snap into place.

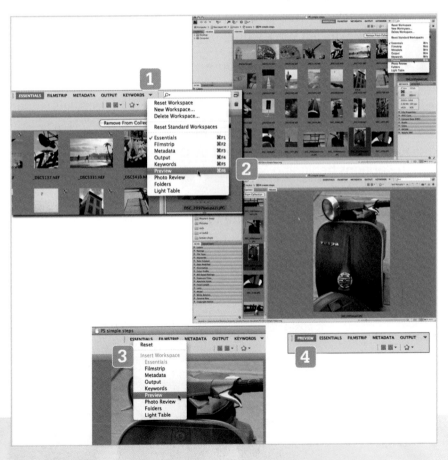

 HOT TIP: You can reorganise all of the workspace buttons in this fashion. You can also drag buttons into position. The entire button bar can be resized by dragging the dotted vertical double bar immediately to the left of the first button.

Expand the thumbnail view and save the new workspace

1 Position the cursor over the vertical bar between the Content and Preview tabs. The cursor will turn into a double arrow.

2 Press and hold down the mouse button, then drag the vertical bar to the right until the content tab appears to be about the same width as the Favorites and Folders tab set. Release the mouse button.

3 Chances are the Content panel will contain two columns of small thumbnail images. We'll make them bigger: locate the thumbnail slider in the bottom margin of the screen. Move the slider to the right (or left) until the thumbnails in the Content tab are a size you can work with.

4 From the Window menu, choose Workspace, New Workspace ...

5 Enter a useful name (e.g. Photo Review) in the New Workspace dialogue box. Be sure to leave the boxes checked next to the options beginning Save Window Location and Save Sort Order.

HOT TIP: Sometimes, all you need to find an image quickly is a layout with lots of thumbnails. If you hit the Tab key, Adobe Bridge will expand the current Content panel and hide away all others. Hit the Tab key again and you return to the previous view.

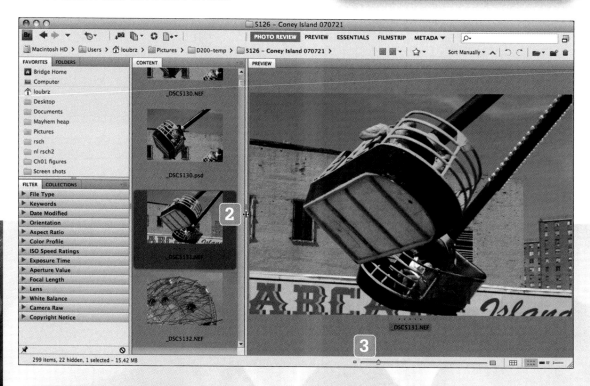

Download files from your camera

Adobe Bridge has a built-in tool called Adobe® Photo Downloader, which allows you to copy files from your camera on to your computer's hard disk. Adobe Photo Downloader can even help you organise those images by performing such optional tasks as dividing them among separate folders based on the date they were shot.

Of course, there are several ways to get files into your computer from your camera. If you are already comfortable using another way, it is not imperative that you stop doing that and use Adobe Photo Downloader instead. However, it is a useful tool with some features that can make simple work of the process.

1 From the File menu, select Get Photos from Camera

2 Set options as needed:

- Menu to select media (A). This will have more than one option if you have more than one card attached to the computer at the same time.

- Click Choose ... to specify where your files will be saved (B).

- Options to segregate your files into separate folders (C).

- Option to rename your files as they are downloaded (D).

- Tick this to show the files in Adobe Bridge when they've finished downloading (E).

3 Click Get Photos.

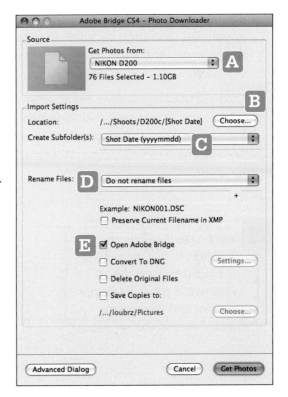

HOT TIP: Although we refer to the process as getting files from your camera, it's actually not a great idea to connect the camera directly to the computer and download that way. A better approach is to get a memory card reader that matches your camera's format (usually Compact Flash or SD, though there are others). You plug the card into the reader, and the reader into your computer. Downloading that way will be faster and won't drain your camera's batteries.

Set Preferences

The preferences you set in this section are optional. You may or may not find them useful, depending upon your style of work.

1 From the Adobe Bridge CS4 menu, select Preferences ... The Preferences window will appear.

2 Click in the box on the left side of the window to select a page of preferences to edit.

3 Change as many pages of preferences as you like, and then click OK to save the changes or Cancel to ignore them.

HOT TIP: Two sets of preferences that are not managed through the Preferences panel are Colour settings and Workspaces.

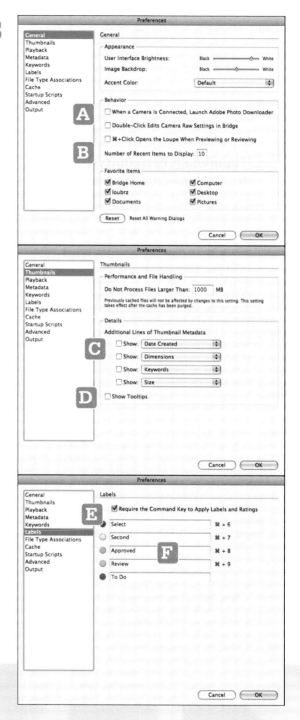

General Preferences page:

- When a Camera is Connected, Launch Adobe Photo Downloader (A). This tells your computer to launch Adobe Bridge and start Adobe Photo Downloader whenever you plug a card reader (with a card in it) into the computer.
- Number of Recent Items to Display (B). This controls how many items appear in the sub-menu that appears when you choose Open Recent from the File menu.

Thumbnails Preferences page:

- Show Date Created (C). Show the date created below the thumbnail in the content panel.
- Show Tooltips (D). This shows the name, date created, date modified and other metadata in a little box that appears when you hold the cursor over a thumbnail in the content panel.

Labels Preferences page:

- Require the Command Key to Apply Labels and Ratings (E). When this is ticked, the keystroke to assign a 5-star rating is Command + 5. When it isn't ticked, you just hit the 5 key.
- The labels are editable (F). Click in the boxes and change the text associated with each colour-coded label as you wish.

3 Work with the Brush tool

Introduction

Many tools in Photoshop, such as the Clone Stamp, the Healing Brush and the Eraser tool, are based on the Brush tool. In this chapter, we'll explore some of the characteristics of the Brush tool and some of its variants.

The screenshots for the tasks in this chapter are based on the Basic Photoshop layout that was established in Chapter 1, and assume you're working in the Application Frame mode. If you hold the mouse button down on the Window menu, a tick should appear next to application frame. If it doesn't, select Window, Application Frame from the menu bar.

Create a new document

Here, we'll create a new document to experiment with. The dimensions and presets you choose are not critical. The point is to be aware that the option exists.

1 Select File, New . . . from the menu bar. A dialogue box will appear.

2 Select Photo from the Preset menu.

3 Select Landscape, 2 × 3 from the Size menu.

4 Click OK.

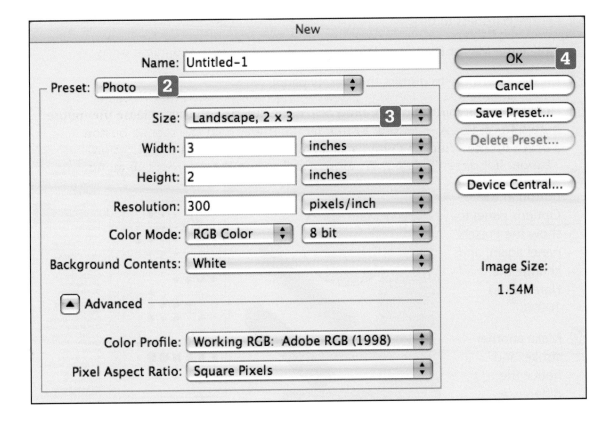

HOT TIP: You have the option to give your file a name before you open it for the first time, or name it later. It's OK to leave the name untitled.

Use the Brush tool

1 Go to the Tools panel and hold down the mouse button on the Brush tool until a fly-out menu appears, then select Brush Tool from the menu.

2 In the Options panel, click the button next to the word Brush to display the Brush Presets panel.

3 In the upper right corner of the panel, click the small triangle to display its menu, and select Small Thumbnail.

4 Click on a brush preset in the panel (e.g. Soft Round 21 pixels).

5 Set the Hardness to 0%.

6 Notice the Master Diameter slider.

7 Hit the Return key to dismiss the Presets panel.

8 Hold the mouse button down, drag across the canvas and then release the mouse button to create a brush stroke.

9 Click the Brush button in the Options panel to show the Presets panel again, and change the Hardness to 100%.

10 Make another stroke, and notice the difference.

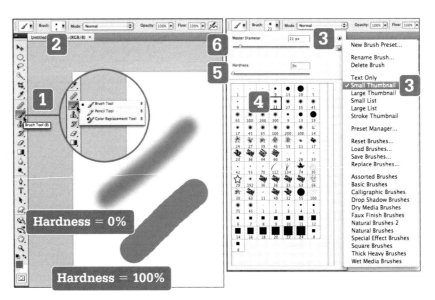

Hardness = 0%

Hardness = 100%

 DID YOU KNOW?
If you hold the mouse still over a brush preset thumbnail, a tool tip will appear, telling you the name of that preset.

HOT TIP: Tap the letter b on your keyboard to select the Brush tool. You can hold the shift key down while you tap b repeatedly to cycle through the various Brush tools.

Use the Brushes panel

Beyond presets, there is a wide range of additional controls for the Brush tool. Those controls can be found in the Brushes panel.

1 Tap the letter b on your keyboard to activate the Brush tool. Notice that the Tool Options panel has updated.

2 If you're seeing the Pencil tool or the colour replacement brush, hold the shift key down and tap b until you see the Brush tool appear in the Tools panel.

3 Sitting by itself, towards the right side of the Tool Options panel, is an icon for the Brushes panel. Click on it.

4 If not already present, the Brushes panel will install buttons into the panel dock and the panel will expand.

5 To close the Brushes panel, either click on the double arrow at the top right of the tab set or click its button in the panel dock.

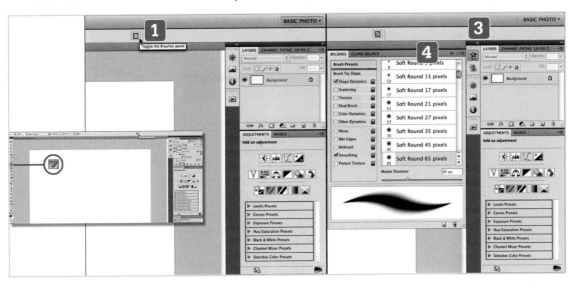

? DID YOU KNOW?

The box on the left side of the Brushes panel shows groups of controls that you can access by clicking on them. The brush presets control works the same way as the control that you saw in the previous example. The shape control is very useful for advanced painting techniques. Functions such as Shape Dynamics, Texture and Wet Edges can be switched on and off by ticking the box next to them. If you attach a drawing tablet to your computer, many of these functions will respond to stylus pressure and tilt.

Use default foreground and background colours

The default foreground colour is black, and the default background colour is white. To use them, you can click on a control in the Tools panel, or even faster, you can tap the letter d on your keyboard.

1 Locate the colour picker controls near the bottom of the Tools panel.

2 To set the default foreground and background colours, click the small black and white icon above the foreground and background colour indicators. That sets black as the foreground colour and white as the background colour.

3 Optional: to exchange foreground and background colours, click the bent arrow icon. That makes white the foreground colour and black the background colour.

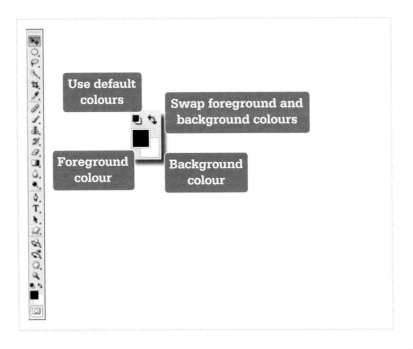

HOT TIP: Instead of clicking the icons in the panel, you can tap d to set the default colours, and x to swap foreground and background colours.

Pick foreground and background colours

The Color Picker in Photoshop is a versatile tool for selecting colours, and it is always within easy reach.

1 Click either the foreground colour icon or the background colour icon. The colour picker dialogue will open, indicating whether you are setting the foreground or background colour.

2 To select a range of colours to work with, click in the vertical colour band.

3 Once the range of colours is selected, click in the coloured box to select a colour.

4 Click OK.

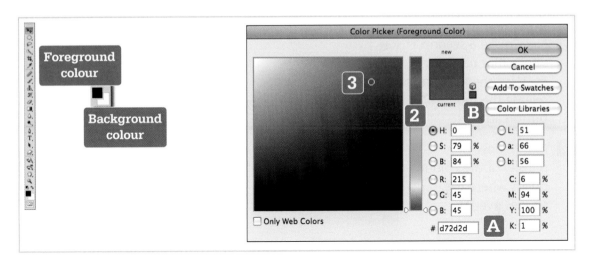

 HOT TIP: Sometimes, you will need to use a specific colour. Instead of clicking in the colour box, you can enter a Web colour in the box marked #, or enter RGB or CMYK values in the appropriate places (A). You can also select colours that are industry-standard for commercial printing, such as Pantone colours, by clicking on the Color Libraries button (B).

Use the Brush tool with opacity

By using the Brush tool at low opacity you can build up colour slowly. In photographic work, this is especially useful for working with masks.

1 Select the Brush tool from the Tools panel.

2 Locate the Opacity field in the Tool Options panel.

3 Click in the field, and enter a value (e.g. 30).

4 Hit the Return key to set the value.

5 Make one stroke on the canvas with the Brush tool, and release the mouse button.

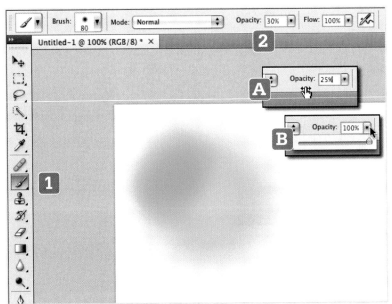

6 Now make a second stroke that partially overlaps the first, and release the mouse button again.

7 Notice how the density of the colour builds where the strokes overlap.

 HOT TIP: Two other ways to change the opacity are as follows:

- Press and hold down the mouse button on the word Opacity, and drag to the left or right, then release when the desired percentage is showing (A).
- Click on the blue button on the right edge of the Opacity field. A slider will appear (B). Drag the slider to the desired percentage, and hit the return key to commit the change.

 HOT TIP: Rather than clicking at all, you can control the brush via the keyboard.

- To make the brush smaller, hit the [key (left square bracket).
- To make the brush larger, hit the] key (right square bracket).
- Hit numbers 1 to 9 to set the opacity between 10% and 90% respectively, e.g. hit 3 to set the opacity to 30% or 5 to set the opacity to 50%.
- Hit number 0 to set the opacity to 100%.

Use the Airbrush

When you set the Brush tool in Airbrush mode, the Airbrush applies increasingly more colour as long as you hold down the mouse button. If you inspect the Brush Presets panel closely, you will notice that some of the presets are Airbrush settings, and some are settings for the regular Brush tool.

1 Click the Brush tool icon in the Tools panel.

2 Click the Airbrush button in the Tool Options panel. Notice that the Airbrush button is a darker shade of grey when the Airbrush is active.

3 Adjust the Opacity using any of the techniques mentioned in the previous example.

4 Adjust the Flow using any of the same techniques you use to adjust the Opacity.

5 Press and hold down the mouse button in one place on the canvas. Notice how the colour spreads beyond the outer edge of the brush.

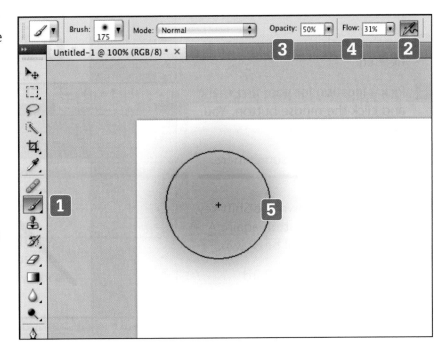

HOT TIP: Flow controls how quickly colour is applied to the canvas, while Opacity controls the density of the colour. When the Airbrush is active, hitting 0 to 9 on your keyboard changes the Flow, rather than the Opacity. Usually, you want to set the Flow to 100% if you're not using the Airbrush.

DID YOU KNOW?

Working with the Brush tool in Airbrush mode can be a bit difficult to control, and many avoid using it altogether. If you accidentally select an Airbrush preset, you can switch out of Airbrush mode simply by clicking the Airbrush button in the Tool Options panel.

Show rulers

You can show rulers when you need to do precision work. The rulers can be set to several different measurement scales.

1 To show rulers, choose Rulers from the View menu.

2 To change the ruler scale, Control-click [right-click on the PC] on one of the rulers.

HOT TIP: The keyboard shortcut for View, Rulers is Command + r [Ctrl + r on the PC].

Add guides

Guidelines can be used to align things visually. You can drag guides into place, or place them at a precise location.

To drag guides, do the following:

1 Hold the mouse button down on the top ruler, and drag downwards. A guideline will follow the cursor down from the ruler.

2 Release the mouse button to place the guide.

3 Drag another guide from the left ruler.

To place guides in a specific location, do the following:

4 Choose View, New Guide ... from the menu bar. The New Guide dialogue will appear.

5 Click Horizontal or Vertical to select it.

6 Enter a position.

7 Click OK.

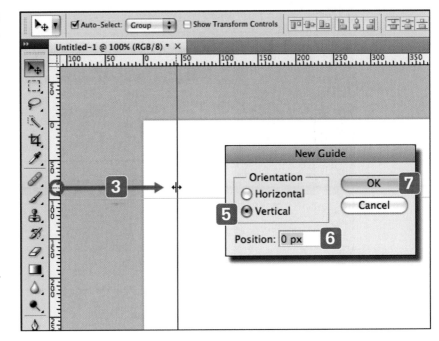

 HOT TIP: When you add a guide, the New Guide dialogue assumes you want to use whatever measurement scale the ruler is currently set to, but you can use different measures if you need to. For example, if the rulers are set to pixels and you want to add a guide at the 50% mark, type 50% into the box, and click OK. Use the following abbreviations to specify units in the New Guide dialogue: px, in, cm, mm, pt, pica, and %.

Reposition or remove guides

1 Select the Move tool from the Tools panel.

2 Place the cursor over the guide.

3 Hold down the mouse button and drag the guide to its new location, then release the mouse button.

4 To remove a guide, drag it back to the ruler that it came from.

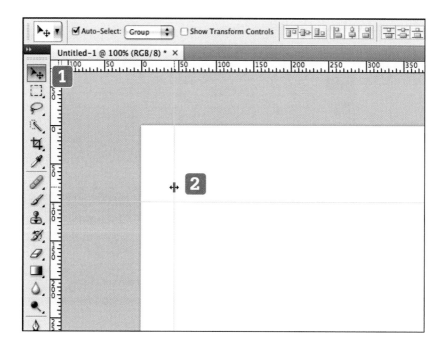

Use Snap

With Snap turned on, the Brush tool will gravitate towards the guidelines, which can make some drawing, painting and positioning tasks much simpler.

1 Hold down the mouse button on the View menu to confirm that a tick appears next to Snap. If there is no tick, pull down on the menu and select Snap.

2 Hit b to select the Brush tool.

3 Stroke the brush along a guideline, and notice how the stroke follows the line.

4 Make a second stroke that starts off following a guideline, but then pull the cursor away from the guideline until the brush breaks away and follows its own path.

5 Optional: to turn off Snap, choose View, Snap from the menu bar, so that the tick doesn't appear.

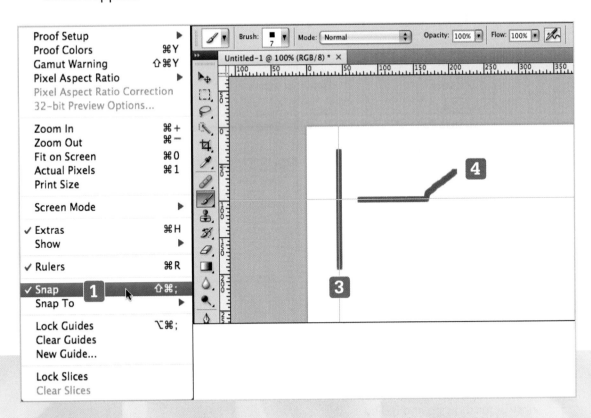

Hide or remove guides

1 To temporarily hide guides, choose View, Extras from the menu bar.

2 To remove all guides, choose View, Clear Guides from the menu bar.

4 Work with layers and groups

Introduction

Working in layers is the secret to the flexibility and power of editing images in Photoshop. Even if the work you produce is an ordinary photograph, and not a montage, using layers will allow you to edit and make revisions more easily.

The tasks in this chapter can be performed on any file that you like, but if you prefer, create a new, blank document as follows: choose File, New... from the menu bar, then select any size that you prefer, and click OK.

Choose a Marquee tool

The Marquee tools are mainstay selection tools. Mostly, you will work with either a rectangular or an elliptical Marquee.

1. In the Tools panel, hold the mouse button down on the Marquee Tool button until the fly-out menu appears.

2. Notice the optional shapes, and choose a rectangular Marquee.

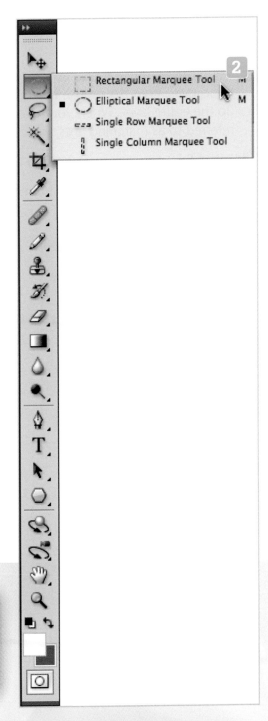

HOT TIP: Tap the letter m on the keyboard to quickly select a Marquee tool. If you hold the Shift key down and tap the letter m, you can alternate between the rectangular and elliptical Marquee tools.

Fill all or part of a layer

1 Click the Create a New Layer button at the bottom of the Layers panel. A new layer will be created.

2 Notice that the thumbnail for the new layer has a grey checkerboard pattern. That is Photoshop's way of indicating that a layer is transparent and contains no pixel data.

3 Using the Marquee tool that you selected in the previous task, place the cursor over the canvas, hold the mouse button down, and drag out a shape that does not take up the entire layer. When you release the mouse button, you will see a pattern referred to as marching ants, indicating the area that you have selected.

4 Select Edit, Fill ... from the menu bar. The Fill dialogue will appear.

5 Choose 50% Gray from the Use menu and click OK. The selected area will fill with grey.

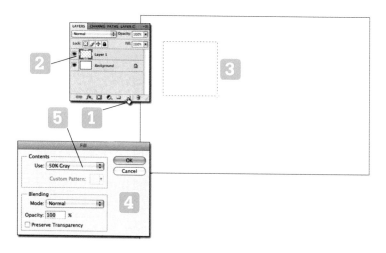

6 Choose Select, Deselect from the menu bar to release the selection. The marching ants will disappear.

7 Notice that the layer thumbnail now shows a small grey rectangle.

8 Click on the background layer, then select Edit, Fill ... from the menu bar again.

9 In the Fill dialogue, choose Colour ... from the Use menu.

10 Select a colour from the Color Picker dialogue and click OK.

11 Click OK to apply the colour to the background layer.

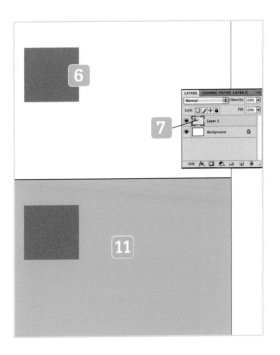

 HOT TIP: You can fill a layer or a selection with a keystroke. Use Option + Delete [Alt + Del on the PC] to fill with the foreground colour, and Command + Delete [Ctrl + Del on the PC] to fill the background colour. If there is a selection active, the keystroke will fill the selected area. Otherwise it will fill the entire layer.

Change layer transparency

The simplest way that layers interact with each other, other than completely covering one another up, is by their relative opacity. When a layer is 100% opaque, it completely covers whatever is beneath it, but we can reduce the opacity of a layer, so that the contents of the layers beneath show through partially.

We will continue with the file that we were working on in the previous task.

1 Click on the layer containing your grey rectangle.

2 Locate the opacity control in the upper right corner of the Layers panel.

3 Change the opacity of the layer to 33%.

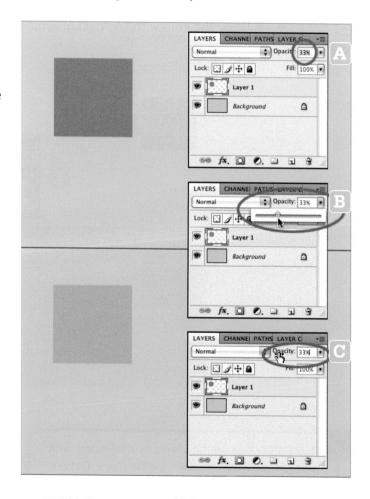

HOT TIP: There are several ways to change the opacity for a layer. You can click in the box and type a value (A). You can click on the blue button at the right edge of the field, adjust the slider that appears, and hit the Return key (B). Or, you can hold down the mouse button on the word Opacity and drag to the right or to the left to change the value (C).

Duplicate the background layer

When you first open a photo, the background layer will contain the original version of the image. To keep a pristine version of the image embedded in your work file, you will often want to duplicate the background layer and edit the copy.

1 In the Layers panel, hold the mouse button down on the thumbnail for the background layer and drag it to the Create a New Layer button at the bottom of the panel.

2 When the tip of the cursor hits the button, it will change shape and the button will darken. Release the mouse button. Your new layer will be created.

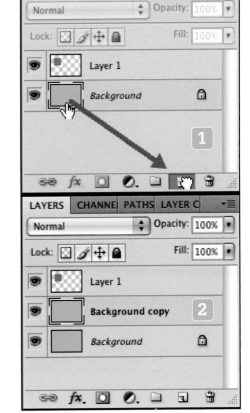

HOT TIP: The Liquify and Patch tools, along with the Shadows/Highlights adjustment, are best applied to a copy of the background layer.

Reorder layers

The stacking order of layers and their relative opacities will make a big difference in the overall appearance of your image. You can easily reorder layers by dragging their thumbnails.

1 Click on the background copy layer that you created in the last task.

2 Hit the b key to select the Brush tool.

3 Hit the d key to select default colours, then hit the x key to make the foreground colour white.

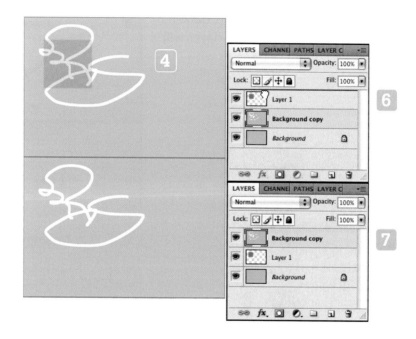

4 Paint a shape that passes under the grey rectangle, and notice that some of the painting shows through the translucent grey layer.

5 Click on the layer containing the grey rectangle, and change its opacity to 100%. Notice the change in appearance.

6 Hold the mouse button down on the thumbnail for the Background copy layer and drag it above the grey rectangle layer. When you see a thick horizontal line appear above the layer containing the grey rectangle, release the mouse button.

7 The layers will rearrange.

8 Notice the appearance of your composition.

9 Change the opacity of the Background copy layer to 60%, and notice the appearance change.

10 Drag the Background copy layer back beneath the grey rectangle layer, and notice the appearance, especially of the white lines.

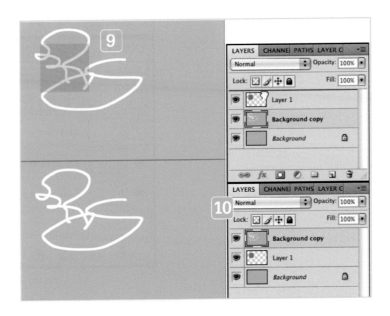

Toggle a layer's visibility

Toggling a layer's visibility is a good way to assess how your edit is progressing and what to do next. You can turn the layer on and off repeatedly to get a sense of before and after.

1 Click the eyeball icon on the left edge of any layer to toggle its visibility off.

2 Notice that the eyeball icon has disappeared, and that the layer is not visible on the canvas.

3 Click the empty square at the left edge of any layer to make the layer and the eyeball icon visible again.

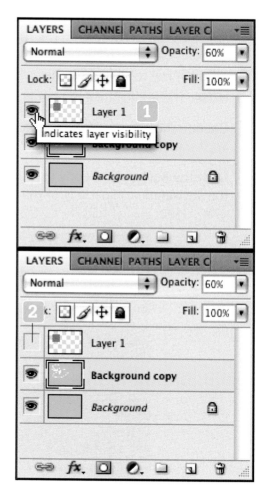

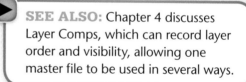

HOT TIP: Whatever you see on screen is the way that file will look when you print it or save a flattened or JPEG version.

SEE ALSO: Chapter 4 discusses Layer Comps, which can record layer order and visibility, allowing one master file to be used in several ways.

Nudge a single layer

Beyond changing the stacking order of layers, you can reposition the contents of a layer by nudging it with the Move tool.

1 Click on the layer that you want to nudge the contents of.

2 Hit the v key to switch on the Move tool. Notice the shape of the cursor.

3 Hold down the mouse button and drag the layer contents to their new position.

4 Release the mouse button.

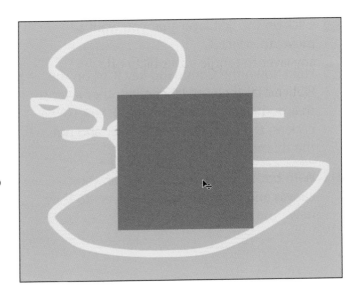

HOT TIP: When you press the Command key [Ctrl on the PC], the cursor temporarily becomes the Move tool. That can be a handy feature, but it's also something to watch out for when you're using any brush-based tool. If you're using a Brush tool and suddenly notice that your layers are out of kilter, it's probably because you accidentally pressed that key.

? DID YOU KNOW?

Photoshop CS4 has a feature called spring-loaded tools. Holding down the letter key that corresponds to a tool temporarily switches that tool on. When you release the key, the preceding tool is reactivated. So, if you're using the Move tool and need to briefly use the Brush tool, just hold down the b key and paint, and then release the key.

Nudge two layers together

You can reposition the contents of two layers as if they were linked, simply by selecting the two layers before you use the Move tool.

1. Click on the first layer that you want to move, to select it.

2. Hold down the Command key [Ctrl on the PC] and click on the label of another layer so that both are selected. It is important to click on the label part of the layer and not the thumbnail.

3. With both layers selected, click on the canvas and drag to move the layers to their new position.

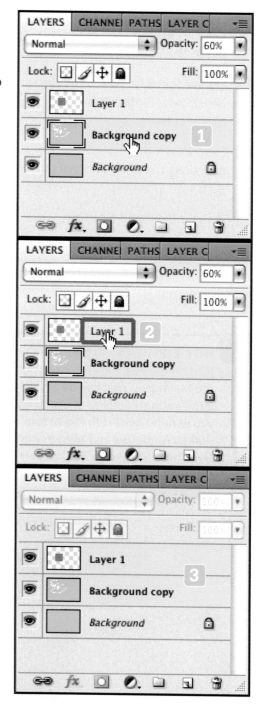

HOT TIP: The background layer is locked and can't be nudged. You can convert the background layer into an ordinary layer by double-clicking on its thumbnail.

Link layers

Once you have selected several layers, you can link them. When layers are linked, they all move together whenever you nudge any of them. Photoshop indicates which layers are linked with an icon in the Layers panel.

1 Select the layers that you want to link as you did in the previous task.

2 Locate the link icon at the bottom of the Layers panel and click on it.

3 Notice the link icons in the Layers panel.

4 Click on either layer, and notice that the link icon appears next to the layer that it is linked to.

HOT TIP: Instead of linking layers, you can group them. When layers are linked or grouped, they move together, but when they are grouped, you can also show or hide all of the grouped layers with a single click.

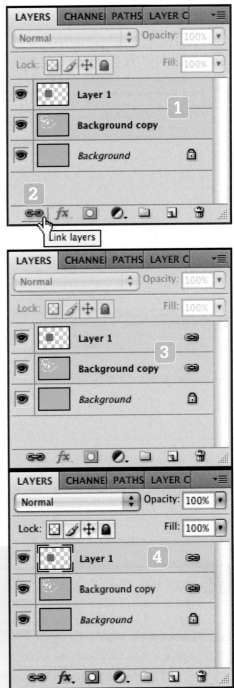

Group layers

Groups of layers can move together as if linked, but groups also operate like layers. For example, groups have visibility and opacity attributes. One of the easiest ways to create a group is to select the layers first, and invoke a keystroke to place them inside the group in one operation.

1. Select the layers to be included in the group using the same technique outlined earlier.

2. Use Command + g [Ctrl + g on the PC] to create the group.

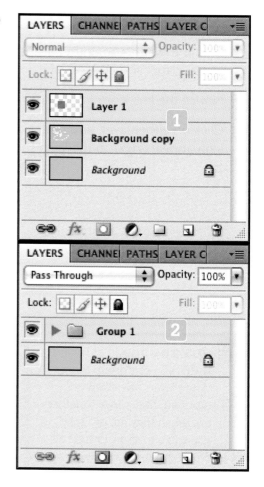

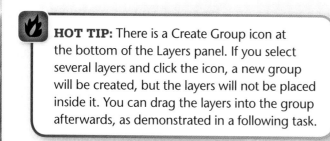

Expand or collapse a group

Collapsing your groups can make your Layers panel much less cluttered. On other occasions, you can expand the group to rearrange its layers or simply to be clear about its contents.

1 Click the triangle on the left side of the group to show its contents.

2 Click the triangle again to collapse the group.

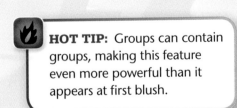

HOT TIP: Groups can contain groups, making this feature even more powerful than it appears at first blush.

Add a layer to a group

When a group is expanded, you can add a layer to it directly, or you can drag layers into a group at any time. We'll look at this in three ways.

1 If the group is expanded, click the triangle to collapse the group.

2 Click on the group to select it.

3 Click the Create a New Layer button at the bottom of the Layers panel. A new blank layer will appear above the group.

4 Press the mouse button down on the thumbnail for the new layer and drag the layer on top of the group. When a rectangle surrounds the group, release the mouse button. The layer will be added to the bottom of the stack inside the group.

5 Click on the group's triangle to expand it.

6 Click on the background layer to select it.

7 Click the Create a New Layer button. A new blank layer will appear above the background layer.

8 Press the mouse button down on the thumbnail for the new layer and drag it into the group. A thick horizontal line will appear where the layer will be inserted into the group. When you see a suitable location, release the mouse.

9 Click on the group to select it.

10 Click the Create a New Layer button. A new, blank layer will appear at the top of the stack inside the layer.

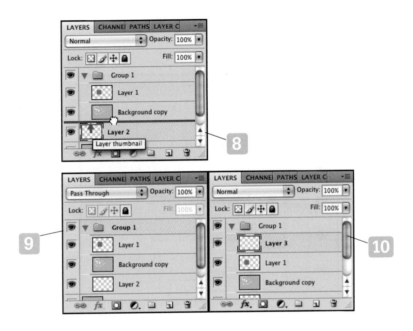

HOT TIP: Not only can you put layers into groups, you can drag groups into groups.

Remove or delete a layer from a group

1. Click the group's triangle to expand it.

2. Press the mouse button down on the thumbnail for the layer that you want to remove, and then drag it upwards.

3. When you see a horizontal line appear outside the group, release the mouse button.

4. If you want to delete the layer instead, drag the layer thumbnail to the trash can icon at the bottom of the Layers panel.

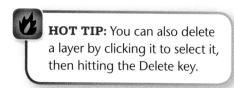

HOT TIP: You can also delete a layer by clicking it to select it, then hitting the Delete key.

Toggle a group's visibility

When you toggle the visibility of a group, all of the layers inside the group toggle together.

1 Click the eyeball icon at the extreme left of the group to hide it.

2 Click the eyeball again to make it visible.

Change the blending mode of a layer or group

Blending modes are very powerful. They allow one layer to alter the appearance of the layers that it sits on top of. The modes are grouped according to how they alter appearances. Aside from Normal, Dissolve, Difference and Exclusion there are groups of modes that darken or lighten in various ways and a third group that increases contrast. A fourth group applies various components of the colour in the selected layer to the layers below.

1 Click to select the layer or group that you want to edit.

2 Choose a blending mode from the menu at the top of the Layers panel.

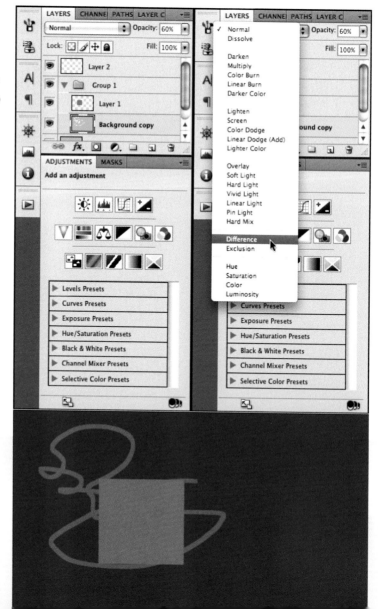

Rename layers and groups

If you use many layers in your work, you will quickly discover how easy it is to lose track of what each layer is for. Giving your layers and groups informative names will save you a lot of time and reduce stress.

1. Double-click on the text part of the layer. The label will turn into a text box.

2. Enter a new name for the layer.

3. Hit the Return key to commit the change.

Note: The process of renaming is the same for both layers and groups.

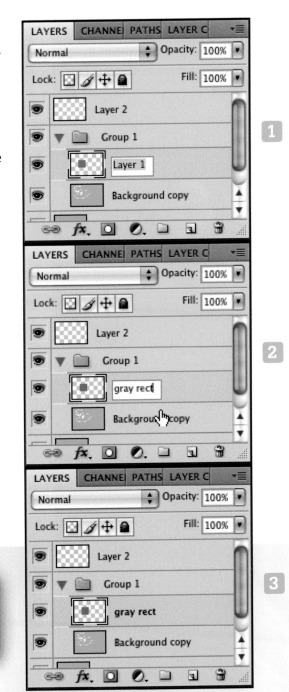

5 Erase, move, crop and undo

Use the Eraser tool

The Eraser tool is straightforward, but has subtle variations to be aware of. In Chapter 9, we will cover the technique of retouching in a separate layer, and you can use the techniques in this chapter along with that. For example, if you decide that part of the retouching in a layer should be redone, it's easy to use the Eraser to remove the part that you don't like. Rather than erase all at once, you can erase with reduced opacity, and you can use a soft brush to create a feathered effect.

1 Create a new document, using File, New ... from the menu bar. Make the file any size you like and click OK.

2 Make a new blank layer and fill part of it with a colour, as outlined in Chapter 4.

3 In the Tools panel, hold the mouse button down on the Eraser tool icon. When the fly-out menu appears, ensure there is a small square next to the Eraser tool. If not, select Eraser Tool from the menu.

4 Make sure the flow is 100% and that the Airbrush option is turned off.

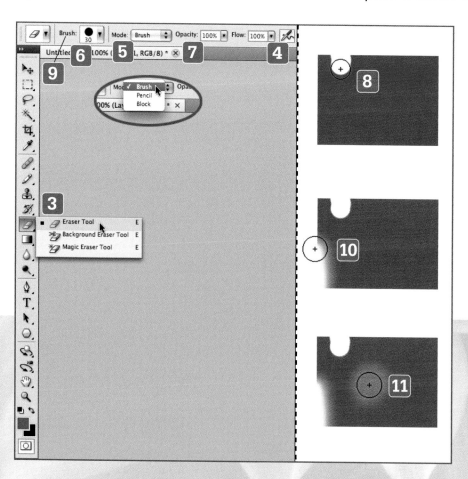

5 Check to see that the Eraser's mode is set to Brush.

6 Click the Brush button to set the Eraser's hardness to 100%, then hit the Return key to conceal dialogue.

7 Set the Eraser's opacity to 100%.

8 Drag the Eraser across part of the coloured area, and notice the appearance of the edge of the erasure.

9 In the Options panel, click the Brushes button to show the Brush Preset Picker, change the hardness to 0%, and hit the Return key to dismiss the picker.

10 Erase another part of the coloured area, and notice the shape of the edge.

11 Change the opacity to 30%, and erase another part of the area. Be sure to release the mouse button, and then go back and stroke over the same area a couple of times. You should see a cumulative effect to your erasing.

 HOT TIP: Erasing permanently deletes pixels, whereas masking has the same effect but only hides pixels.

? DID YOU KNOW?

The Eraser tool also has a block mode, which makes the tool into a hard-edged square that is especially useful for erasing individual pixels when you zoom in. Be sure to experiment with that mode.

Select an area with the Marquee tool and clear it

As an alternative to using the Eraser tool, you can make a selection and use the Delete key to clear out large areas quickly.

1 Click on the layer containing your coloured field to make it active.

2 Tap the letter m on your keyboard to select the Marquee tool, or click on the Marquee tool in the Tools panel.

3 Hold the mouse button down and drag a shape that cuts into your coloured area.

4 Hit the Delete key. The area will clear.

5 Use Select, Deselect from the menu bar to dismiss the selection.

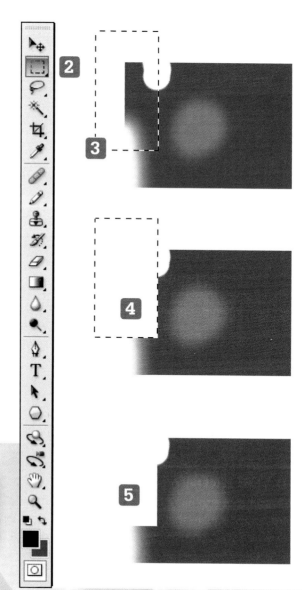

SEE ALSO: Find more detailed information on working with selections in Chapter 11.

Choose a Lasso tool

Photoshop has three Lasso tools in one button. The basic Lasso tool is a free-hand selection tool. You can use it to trace around complex shapes. The quality of your selection is dependent upon how steady your hand is. The Polygonal Lasso creates a shaped selection based upon the points that you click. The Magnetic Lasso looks for light/dark contrast nearby, and creates a selection based on tonal differences.

1 Hold the mouse button down on the Lasso tool icon. A fly-out menu will appear.

2 Select the Polygonal Lasso tool. We'll use that in the next task.

HOT TIP: Hold down the Shift key and tap l repeatedly to select the Lasso tool of your choice.

Select and move a section using the Polygonal Lasso

The Polygonal Lasso creates straight-edged shapes by clicking.

1 Click several times in succession to create a shape with the Polygonal Lasso tool.

2 When you bring the cursor back close to the starting point, it will change shape to indicate that the path will close up.

3 Click to close the path. The selection will be outlined with a moving pattern referred to as marching ants.

4 With the Lasso tool still selected in the Tools panel, press and hold the mouse button and drag the selection a short distance, then release the mouse button. The selection itself will move, but not the contents.

5 Hold down the Command key [Ctrl on the PC] and drag the selection. Notice that it now tears out a piece in the shape of the selection.

6 Choose Select, Deselect from the menu to release the selection.

 HOT TIP: This technique works with any selection, not just those created with the Polygonal Lasso.

Select and copy part of a layer

In the previous example, we tore a section out of the layer and relocated it, using a selection. Sometimes, you want to duplicate something in a new location, rather than moving it.

1 Using a moderate-size hard brush, make a dot in the clear area of your page.

2 From the Tools panel, select the Elliptical Marquee tool.

3 Make a selection that surrounds the dot you just made.

4 Hold down the Option + Command keys [Alt + Ctrl keys on the PC], then press and hold the mouse button down inside the selection.

5 Drag the copy to a new location and release the mouse button.

6 Choose Select, Deselect from the menu to release the selection.

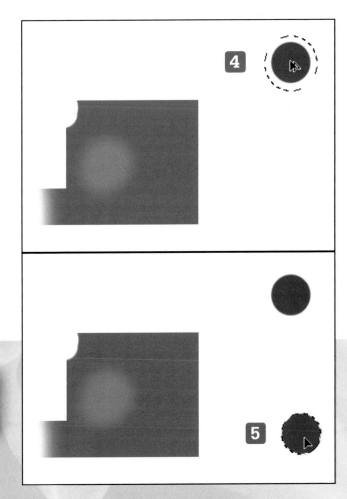

HOT TIP: A shortcut for Select, Deselect is Command + d [Ctrl + d on the PC].

Use the Crop tool

Use the Crop tool simply to trim the edges off your canvas, or to completely reshape it.

1 Select the Crop tool from the Tools panel.

2 In the Tool Options bar, leave the Width, Height and Resolution fields clear. If you have entered values into any of those fields, press the Clear button.

3 Position the cursor in one corner of the area that you want to select.

4 Press and hold the mouse button, and drag diagonally towards the opposite corner of the area that you want to select.

5 When you have an approximate shape, release the mouse button. Handles will appear around the selection.

6 Use the handles on the outline to reshape the selection.

7 When you are satisfied with the shape, hit the Return key.

8 The cropping will be applied.

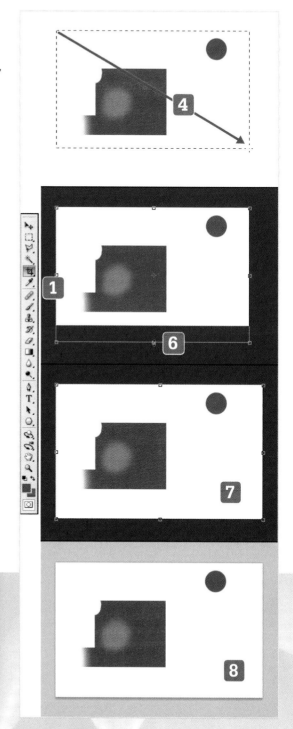

HOT TIP: When you crop in Photoshop, you throw away the original pixels, so be sure to keep an original, uncropped version of the file available, in case you later decide you don't like the way you have cropped the image. If you use the Crop tool in Camera Raw, your original image is not thrown away. You can reopen the file in Camera Raw and either discard or change the cropping.

Use the History panel

As you work in Photoshop, each action that you take is tracked, and the most recent actions are displayed in the History panel. How many appear there depends upon the History States preference you set in Chapter 1. The panel is a super-undo allowing you to step backwards through your edits to reverse a problem.

1 Click on the text or the icon on any row in the History panel list to move to a different history state. You can move forwards or backwards in the history.

2 Do not click in the boxes along the left edge of the History panel list. Clicking there loads the History Brush; it does not change the history state.

3 If the list of states is sufficiently long, the scroll bar will be active. Use the scroll bar to navigate between the history states in the list.

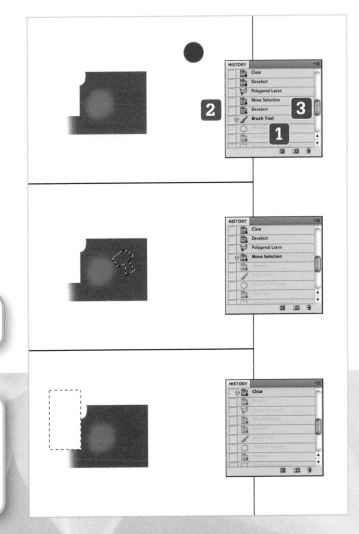

HOT TIP: History states are lost when you close the file.

? DID YOU KNOW?
Two advanced features that you might want to explore on your own are History Snapshots and the History Brush.

6 Work with type

Introduction

Even if your prime interest in Photoshop is working with images, there are a number of situations where you may want to combine images and text – adding a copyright notice to the bottom of your images or creating a promotional piece, for example. In such cases, you will find Photoshop's Type tools to be very useful.

Choose a Type tool

The two main variations of the Type tool produce either horizontal or vertical text. Aside from the controls in the Tool Options panel, you can further refine text with the Character and Paragraph panels.

1 In the Tools panel, press and hold the Type tool button to expose the fly-out menu.

2 Notice that there are separate tools for making horizontal and vertical text.

3 Select the Horizontal Type Tool.

4 Select Window, Character from the menu bar to add the Character and Paragraph panels to the dock.

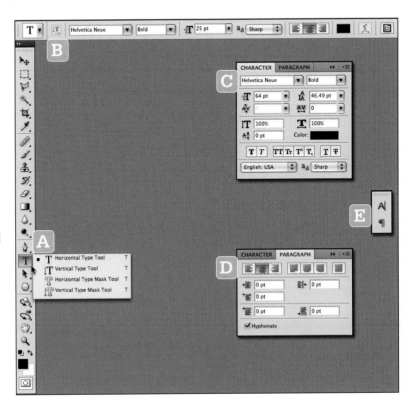

? **DID YOU KNOW?**

Key elements of the Type tool (A) include the Options panel (B). The Character panel (C) and the Paragraph panel (D) can be added to the panel dock (E).

HOT TIP: Tap the t key to select the Type tool.

▶ **SEE ALSO:** The Type Mask tools are used to create a selection, which can be used to create a mask or clear parts of an image. See Chapter 11 for more on working with selections.

Use the Type tool to make straight-line text

Use this method to add short bits of text to your image.

1 With the text tool selected (see previous task), look at the Options panel and check the font, point size and text alignment.

2 Position the cursor over the canvas and click.

3 An insertion point will appear.

4 Type a couple of words or so. Notice the blinking cursor.

5 Hit the Enter key, or click on a thumbnail in the Layers panel to commit the text.

6 Notice that a new text layer has been created in the Layers panel.

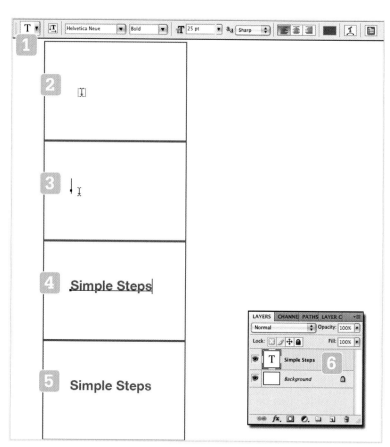

HOT TIP: While the Text tool is active, you cannot use the letter keys to access other tools in the Tools panel. Don't forget to commit the text first.

Use the Type tool to make wrapping text

To make wrapping text, you define a box that the text fits inside. You can really make the box any size, since the box can be resized later.

1 Select the Type tool in the Tools panel, position the cursor over the canvas, hold down the mouse button, and drag a rectangular shape.

2 When you are happy with the shape, release the mouse button.

3 Type enough text into the box to cause it to wrap.

4 Use the handles on the text box to reshape it.

5 Notice that the text reflows to fit the box, and that it is clipped when the box is too small.

6 Hit the Enter key or click a layer in the Layers panel to commit your edits.

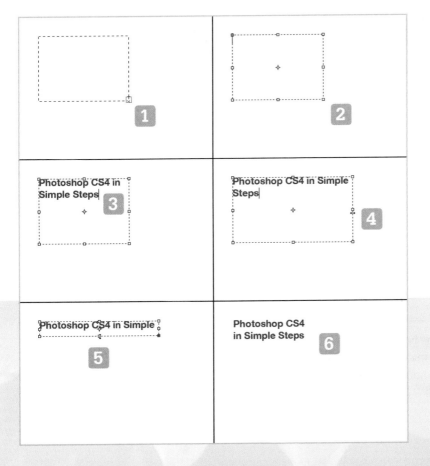

Alter type with the Options and Character panels

The Options panel and the Character panel offer additional ways of editing straight-line or wrapping text. We'll use another shortcut to begin editing the text.

1. Locate the layer containing the text you wish to edit and double-click on it. The text will become selected and the Tools Panel will automatically switch to the Type tool.

2. Leave the text selected, and use the Tool Options panel to change the font size and the alignment.

3. Double-click on one word in the text to select it.

4. Click on the colour chip in the Tool Options panel to show the Select text color dialogue, click on a new colour, and then click the OK button.

5. Change the point size of the selected text using the control in the Tool Options panel.

 HOT TIP: To get the line spacing to look nice in this example, the entire middle line was selected, and the leading was adjusted until everything matched up.

6 Select all of the text using Command + a [Ctrl + a on the PC].

7 To show the Character panel, either click on the Character panel button in the panel dock, or select Window, Character from the menu bar.

8 Experiment with the leading, horizontal scale, and vertical scale controls in the Character panel.

9 Click and drag to select all or part of a single line of text.

10 Adjust the tracking to see how it affects the spacing between letters, shortening and lengthening the line.

11 To commit the changes, hit the Enter key or click on a layer in the Layers panel.

 HOT TIP: Savvy typographers will vary the tracking of text line by line to make good-looking justified text. It often works much better than setting the alignment of the text to fully justified.

Edit and reshape wrapping text

If you have committed your wrapped text, you can still reshape it.

1. Select the Type tool from the Tools panel.

2. Position the cursor over the text that you want to edit. Notice that the cursor changes to an I-beam shape.

3. Click in the text to begin editing.

4. Edit the text as desired.

5. Drag the resizing handles to change the shape of the text box.

6. Hit the Enter key when you are satisfied with the results.

Photoshop CS4 **2**
in Simple Steps

Photoshop CS4 **3**
in Simple Steps

Photoshop Cre- **4**
ative Suite 4 in
Simple Steps

Photoshop Creative Suite 4 **5**
in Simple Steps

HOT TIP: You can also double-click or drag inside the text area to select text that you want to edit.

7 View your document in different ways

Introduction

Some tasks in Photoshop require close work at high magnification, while others require a broader view. While Photoshop's various panels are designed to use only a modicum of space, there are times when the panels still get in the way.

An array of viewing tools allows you to quickly unclutter your screen, work at different magnifications and move around the image easily, even when working at high magnification. The techniques shown here are demonstrated with the windows in Application Frame mode, but they also work with your windows set to the Application Bar mode.

Switch screen modes

Whether you have a 15" screen or a display that is 30" or larger, working in Photoshop entails dealing with the available screen area. Photoshop has three screen modes that give increasingly more space to the image. In full-screen mode even the menu bar goes away.

1 Open any image in Photoshop, and notice the arrangement of panels and menus. This is the Standard mode.

2 Hit the f key once, and the screen mode will switch to Full Screen With Menu Bar mode. Notice that the tabs disappear and that the panels now float above the image.

3 Hit the f key again, and the screen mode will switch to Full Screen mode; the panels and menu bar disappear. Chances are, the background is black, which is not a good colour to use when evaluating pictures.

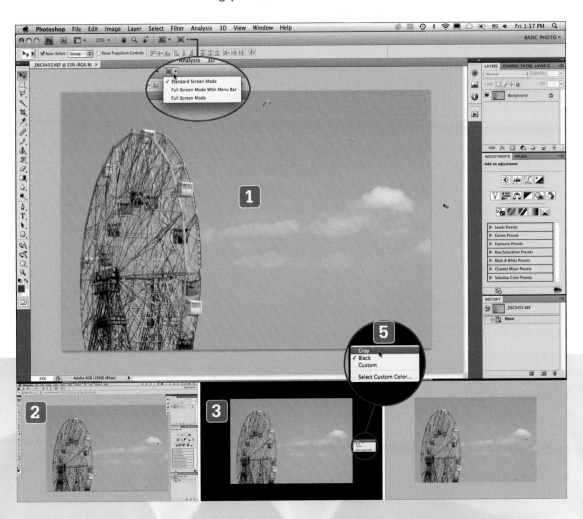

4 If the background is black, hold down the Control key and click on the background (right-click on the PC) to display a menu.

5 Choose Gray from the menu.

6 Hit the f key again, and you return to Standard Screen mode.

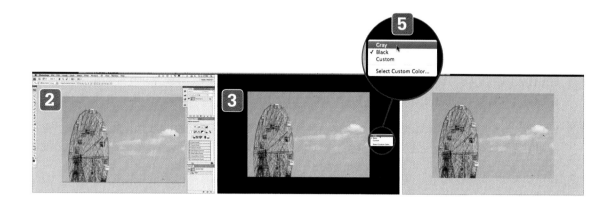

Show or hide all panels

Sometimes, the panels can get in the way of your work. You can hide them away, so that you have more room to work, and still get quick access to them.

1 Hit the Tab key, and the panels will be hidden.

2 If you started with the screen mode set to Standard, notice that there are two dark grey vertical bands at the left and right edges of the work area.

3 Move the cursor over either of these bands, and the band will expand to show its panels.

4 Move the cursor back over the image, and the band will collapse to its compact form again.

HOT TIP: Even though there are no visible bands in either of the full screen modes, the panels will still pop out when you move the cursor close to the edge of the screen.

Rotate and reset the view

The Rotate View tool temporarily displays your work at any angle that you like. It is particularly helpful in situations where brush strokes would be awkward if you left the image in its original orientation. Unlike the Image Rotation command, Rotate View uses the display card in your computer to present your work at a different angle without altering the pixels in your image.

We will use the Rotate View tool as a spring-loaded tool, which is a new feature of Photoshop CS4.

1 In the Tools panel, click the Brush tool, or any tool other than the Type tool or the Rotate View tool.

2 Press and hold the r key to engage the Rotate View tool. The cursor will change shape and the Rotate View buttons in the Tools panel and the Application Frame will become activated.

3 While continuing to hold the r key, press the mouse button down and drag in a circular direction – either clockwise or anti-clockwise.

4 When you achieve the rotation you wish, release the mouse button, then release the r key.

5 Notice that the previously selected tool has become active again.

6 Press and hold the r key to re-engage the View tool.

7 Click the Reset View button to restore the view to the original orientation of the file.

8 Release the r key.

 HOT TIP: If your computer has an older graphics display card, the Rotate View tool may not be available.

 DID YOU KNOW?

The menu command Image, Image Rotation is very different from the Rotate View tool. Using Image Rotation repeatedly, especially at arbitrary angles, can degrade your image, because it is recalculating and changing the pixels in your image each time.

Zoom in or out

A variety of ways to zoom in and out from the image are outlined below. Often, you will zoom in to the appropriate magnification, but need to shift the view one way or another after the case. We will look at two approaches in the next tasks.

1 Hold the Command key [Ctrl on the PC] and tap the + (plus) key a few times to zoom in.

2 Release the Command key when you are done.

3 Hold the Command key [Ctrl on the PC] and tap the – (minus) key to zoom out, and then release the Command key when you are done.

4 Hold the Command key [Ctrl on PC] and tap the 0 (zero) key to fit the image in the current window.

5 Hold the Command key [Ctrl on PC] and the Option key [Alt on the PC], and tap the 0 (zero) key to zoom the image to 100% magnification.

6 In the Tools panel, click the Zoom tool.

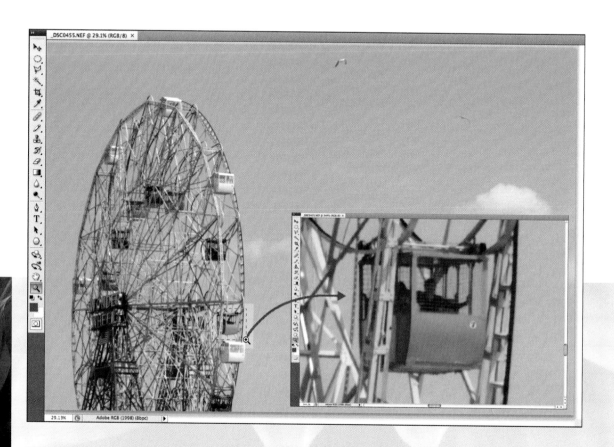

7 Press the mouse button down and drag in a diagonal to select a small area of the image.

8 Release the mouse button, and the view will zoom in to fit the selected area.

9 In the Tool Options panel, notice the pre-set zoom buttons: Actual Pixels, (100%), Fit Screen, Fill Screen, and Print Size.

 HOT TIP: In the Tools panel, you can double-click the Hand tool to zoom out to fit the window, and you can double-click the Zoom tool to zoom in to 100%.

Reposition with the Hand tool

When you are zoomed in close and you need to move a short distance in the image, the Hand tool is perfect for the task. We'll use the keyboard shortcut to get temporary access to the tool.

1 Press and hold the space bar to temporarily shift any tool other than the Type tool to the Hand tool.

2 Press the mouse button down, and drag the cursor in any direction to reposition the view.

3 When you are done, release the space bar. Notice that the tool previously in use is reactivated.

? DID YOU KNOW?

When you zoom in very close, Photoshop will display grid lines to indicate where the individual pixels are: however, the grid feature works only with more recent graphics cards.

🔥 HOT TIP: The space bar shortcut does the equivalent of clicking on the Hand tool in the Tools panel.

Use Bird's Eye view

When you're zoomed in very close and want to go to the other side of the document, it can be time-consuming to slide across with the Hand tool. The Bird's Eye view temporarily zooms out and lets you reposition the view, then zooms back in for you.

1 Make sure you are zoomed in so that the entire image doesn't fit in the screen.

2 In the Tools panel, select any tool other than the Hand tool or the Type tool.

3 Press and hold the h key. Notice that the cursor changes to a hand.

4 Press and hold the mouse button. The view will zoom out and the hand will be surrounded by a rectangle representing the view.

5 Drag the view to a new location and release the mouse button. The view will zoom in on the new location.

6 Release the h key, and notice that the tool you previously selected is active again.

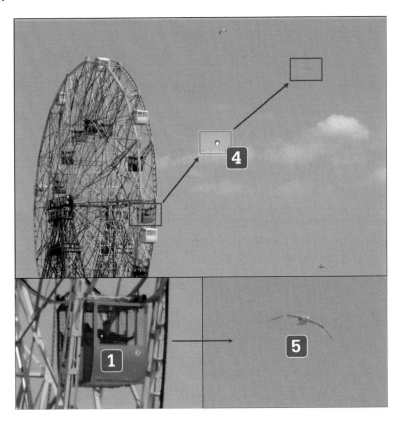

HOT TIP: Bird's Eye view uses the capabilities of your computer's graphics card and may not be available on older computers. If Bird's Eye view does not work, the Navigator panel offers similar functionality. (See the next task.)

Use the Navigator panel

The Navigator panel offers similar functionality to the Bird's Eye view, and is available on all computers, regardless of the graphics card. It also offers several convenient ways to adjust the magnification as an alternative to the methods covered earlier in this chapter.

1 Locate the Navigator panel's button in the dock and click on it. If you cannot find the button, choose Window, Navigator from the menu bar to show the Navigator window.

2 Chances are, the panel is a bit small. Put the cursor over the small triangular area at the lower right corner of the panel, press and hold the mouse button, and drag downwards to expand the Navigator window a bit.

3 Notice that a red rectangle representing the current view appears in the window.

4 Press the mouse button down on the rectangle and drag it to a new location, then release the mouse button. The view will update as you drag the rectangle.

5 Move the slider at the bottom of the panel to change the magnification.

6 Click on the icons to either side of the slider, and notice how the magnification changes.

7 Click in the box at the lower left corner of the panel, and enter a value.

8 Hit the Return key to commit the changes.

9 Click the Navigator panel button in the dock to hide the panel.

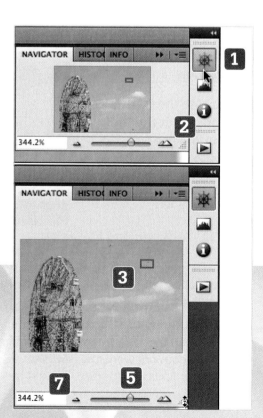

8 Pre-edit in Camera Raw

Move with the Hand tool

The Hand tool in Camera Raw works the same as it does in Photoshop.

1 Click the Hand tool button or tap the h key to engage the Hand tool.

2 Press the mouse button down in the image area and drag to reposition the image.

3 Release the mouse button to complete the move.

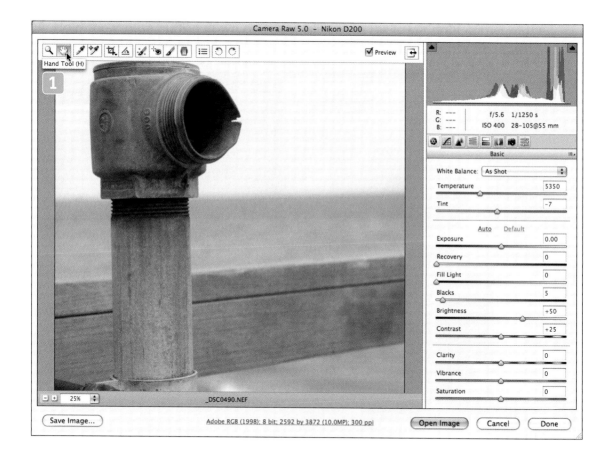

 HOT TIP: To temporarily engage the Hand tool, hold down the Space bar. The previous tool will be restored when you release the Space Bar.

Rotate the image

You can click the rotation icons or use a keyboard shortcut.

1 To rotate anti-clockwise, click the left-hand rotation button, or tap the l key.

2 To rotate clockwise, click the right-hand rotation button or tap the r key.

HOT TIP: Even if your camera automatically rotates images based on how you hold the camera, the feature doesn't work when you point the camera straight up or straight down. Sometimes, you might just want to rotate the image regardless of the 'right' orientation.

Crop an image

Use cropping to reframe your image. Aside from free-form cropping, the Cropping tool in Camera Raw has preset aspect ratios that match classic camera formats, and you can specify your own custom shape as well.

1 Hold the mouse button down on the Crop tool in the upper left corner of the Camera Raw dialogue. A menu will appear.

2 Note that Normal allows you to do free-form cropping and that there are several preset shapes.

3 Choose Custom ... from the menu. A dialogue box will appear.

4 Leave Crop set to Ratio, enter 2.2 to 1 as the ratio, and click OK. This is the shape of 70 mm theatrical films.

5 Hold the mouse button down in the image area, drag out a rough selection and release the mouse button.

6 Notice that Camera Raw has dimmed the part of the image outside the cropped area.

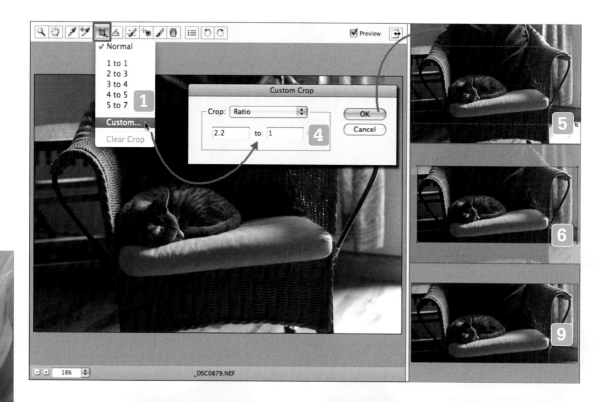

7 Press the mouse button down inside the cropped area, drag and release the mouse button to reposition the cropped area.

8 Click and drag the square handles at the corners of the preview to resize it.

9 Hit the Return key to commit the crop.

 HOT TIP: Cropping in Camera Raw is non-destructive, meaning that the original image data is not thrown away, even if you crop a JPEG or a TIFF. If you change your mind later, you can delete the crop and revert to your original image. If you crop in Photoshop, the data is permanently deleted.

Remove cropping from an image

When you have cropped an image in Camera Raw, Adobe Bridge will display an icon to indicate that the image has been cropped. You can reopen the image in Camera Raw and remove or redo the cropping.

1 Locate a cropped image in Adobe Bridge. An icon appears next to the thumbnails of cropped images in Bridge.

2 Click on the thumbnail and click on the Open in Camera Raw button. The image will open in Camera Raw.

3 Click on the Crop tool button.

4 Hit the Delete key to remove the crop.

5 As an alternative to 3 and 4 above, hold the mouse button down on the Crop tool button to display its menu, and then choose Clear Crop.

6 Click the Done button and note that the preview has been updated in Adobe Bridge.

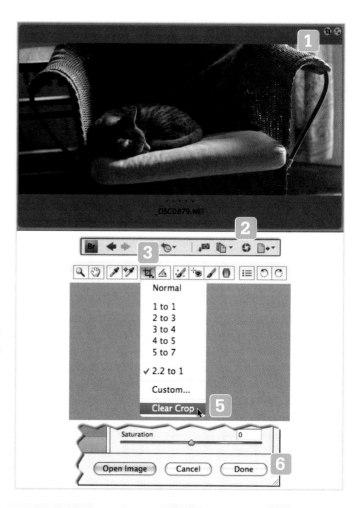

 HOT TIP: If your preferences are set properly, you can simply double-click on a cropped image to open it in Camera Raw, even if the image is a JPEG or a TIFF.

Straighten an image

The Straighten tool allows you to define what is vertical or horizontal in your picture. It then rotates and crops the image so that the sides are square. Like the Crop tool in Camera Raw, Straighten is reversible.

1 Click on the Straighten tool.

2 Press the mouse button down and drag a dotted line with the tool to indicate either the horizon line or a line that should be perfectly vertical.

3 Release the mouse button.

4 Note that the Crop tool is now active.

5 As with the Crop tool before, you can use the corner handles to resize the crop, and you can drag the crop area.

6 Hit the Return key to accept the crop.

Note:
Contrast has been added to make the application of the tool a bit more obvious.

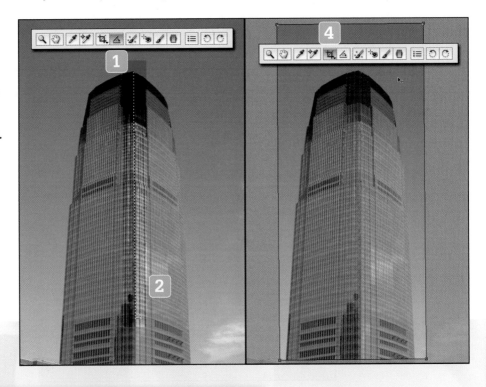

 HOT TIP: When you use the Straighten tool, Camera Raw creates a crop that will be vertical when it opens in Photoshop, but it does not rotate the preview.

Adjust Exposure, Recovery, Fill Light, Blacks, Brightness and Contrast

This set of Camera Raw controls allows you to adjust the tonality of your image. Raw files have a significant amount of latitude, allowing you to recover detail in blown highlights and blocked shadows. By comparison, highlight recovery is not possible with JPEG or TIFF images. Typically, it is best to work from top to bottom with these controls.

1 Move the Exposure slider left or right to make all tones in the image darker or lighter. At some point, the image will look either too light or too dark, or clipping will occur.

2 If you have highlights that are pure white and are missing detail, you may be able to get that detail back with the Recovery slider. Move the slider to the right by degrees until you see the details restored. Notice that at higher settings, some middle tones are also affected.

3 Use the Fill Light control to lighten details in the shadows. Notice how the histogram changes shape as you move the slider.

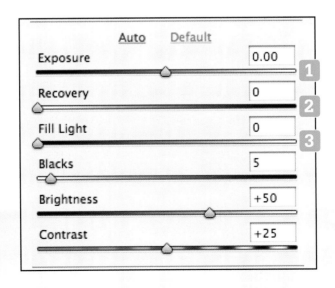

4 The Blacks slider can add substance to a photo that doesn't have any pure blacks. It also operates on the left side of the histogram, but somewhat differently from the Fill Light slider.

5 Use the Brightness slider to adjust the upper middle tones the most. It makes the overall image brighter, but does not shift the shadows and the brightest parts of the image as quickly as the Exposure slider.

6 Use the Contrast slider to increase or decrease the difference between light and dark values. Move the slider both left and right to gauge its effect.

 HOT TIP: Toggle the Preview tick box on and off as you adjust the image to check your progress. It's not always easy to gauge when your adjustments have gone too far.

? DID YOU KNOW?
You can click in the value fields and use the up or down arrow fields to adjust the values in small increments, rather than using the sliders.

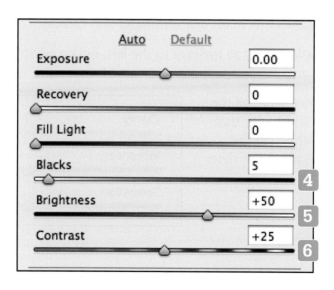

Adjust Clarity, Vibrance and Saturation

These three controls have to do with the richness or purity of the colours and the sense of depth in your image. Clarity increases contrast in a targeted way. Vibrance increases saturation, but protects skin tones and affects more saturated colours more gradually.

1 To use the Clarity control, it is generally best to zoom in to 100% or more first.

2 Move the Clarity slider to the right until you begin to see broad haloes appear around the edges of your details, then move the slider slightly to the left until the haloes vanish.

3 Move the Vibrance slider to the right to increase saturation. Notice how the colours change, particularly any skin tones or colours that are already fairly saturated.

4 Move the Vibrance slider back to zero.

5 Move the Saturation slider to the right and notice how the colours change, and that it is easy to produce unpleasant over-saturated skin colours.

6 Move the Saturation slider all the way to the left, notice what it looks like, and then move it back to zero.

7 Move the Vibrance slider all the way to the left, and notice that hints of colour remain in the image, and then move the slider back to zero.

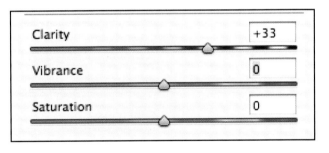

Clarity	+33
Vibrance	0
Saturation	0

HOT TIP: For most purposes, Vibrance is a better choice than Saturation when you want to increase the purity of the colours.

Use Noise Reduction

Digital noise tends to be a problem when shooting at high ISO, and it is more pronounced on cameras with smaller sensor chips. The noise reduction feature in Camera Raw works well, and is simple to use.

There are two aspects of digital noise. Colour noise occurs as bright, coloured dots that appear in a random pattern, particularly in the shadows. Luminance noise is when the pixels are too light or too dark compared with the surrounding pixels.

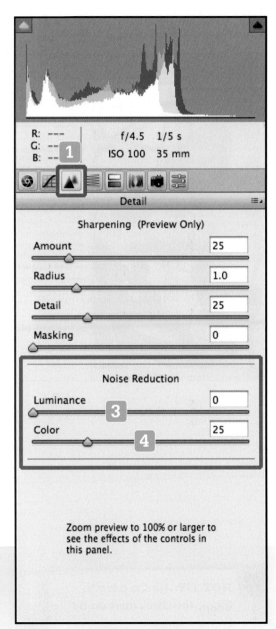

1 Click on the Detail icon to bring up the sharpening and noise reduction controls.

2 Zoom in to at least 100% to see the effects of these controls clearly.

3 Use the Luminance slider to even out luminance noise.

4 Use the Color slider to reduce colour noise.

 HOT TIP: Noise reduction is not a cure-all, and the downside is that it can make your image look softer.

Toggle your preview

Though it has been mentioned among the steps of a few of these tasks, it bears repeating that toggling the preview on and off is a good way to evaluate whether your adjustments are improving the image. Rather than using the mouse to click the tick box, we'll use the keyboard.

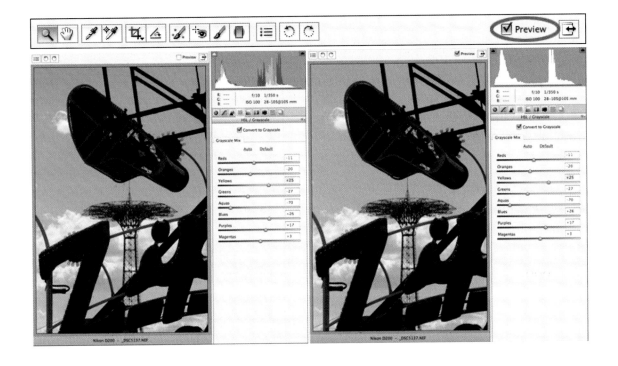

HOT TIP: Hit the p key to toggle the check mark on the Preview box.

Use Auto, Default, Reset and Undo

In the Basic and HSL/Grayscale panel sets, you will see the words Auto and Default underlined. These are useful buttons designed to look like Web hyperlinks. The text in the link is shown in grey when that mode is active.

1 Click Auto to have Camera Raw determine the settings for you. It often does a good job, and you can adjust the settings further once you have applied auto settings.

2 Click Default to return all sliders to their default settings.

3 If you want to return an individual slider to its default setting, double-click on it.

4 If you want to have Camera Raw automatically set the value for a slider, hold down the shift key and double-click the slider.

5 To reset all of the settings for the file, hold down the Option key [Alt on the PC]. The Cancel button will convert to a Reset button. Click the button and then release the Option key.

6 You can use Undo (command + z [Ctrl + z on the PC]) to reverse any slider changes and even the Reset button.

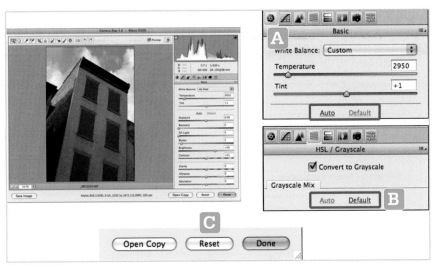

? DID YOU KNOW?

Example (A) shows the Basic panel, using default settings, Example (B) shows the Grayscale Mix panel set to Auto. When the settings are custom, both the Auto and Default controls are displayed in blue. When you hold down the Option key [Alt on the PC], the Cancel button converts into a Reset button (C).

Cancel or save edits without opening the file in Photoshop

In some workflows, you just need to use Camera Raw to make quick basic adjustments for the moment, and put the images aside for later. In other workflows, you may be able to do all of the adjustments and corrections you need in Camera Raw, and you want to bypass Photoshop and create a JPEG or TIFF file directly.

1 If you click the Cancel button, Camera Raw will discard your adjustments.

2 If you want to save your adjustments simply click the Done button.

3 If you click Save Image ... Camera Raw will display the Save Options dialogue.

4 In the Destination section, choose Save in Same Location from the menu or click Select Folder ... to save the file in a new location.

5 In the File Naming section, you have the option to simply use the document name or rename your file in a structured way with up to four parts.

6 Finally, use the Format section to specify what kind of file you want to save and any compression options that might be available.

7 Click the Save button to create the new file, or click the Cancel button if you've changed your mind.

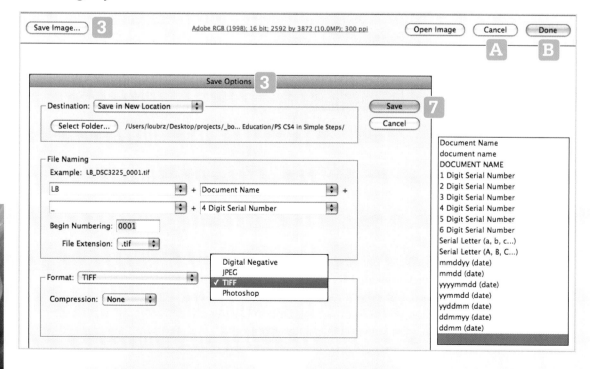

9 Basic retouching

Introduction

There is an art to doing great retouching, and at the root of it all is good basic technique. By retouching on separate layers and working with copies of layers you can retouch your file endlessly without having to worry that something went wrong with your original copy. That gives you the freedom to start afresh at any time.

Duplicate the background layer

Several tools in Photoshop permanently alter the pixels in a layer. By performing these operations on a copy of the background layer of your photo, you create a built-in backup mechanism.

1 In the layers panel, locate the Create a New Layer icon.

2 Hold the mouse button down on the thumbnail part of the background layer and drag it to the Create a New Layer icon, then release the mouse button.

3 Subsequent editing will be done on the copy, leaving the pristine original as a built-in backup.

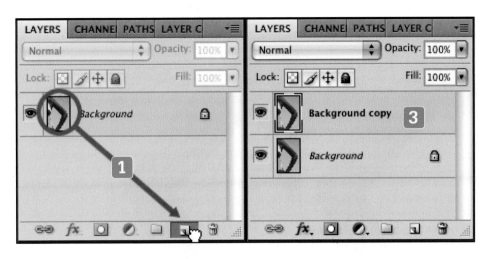

HOT TIP: The Liquify and Patch tools, along with the Shadows/Highlights adjustment, are best applied to a copy of the background layer.

Reshape with the Liquify tool

The Liquify tool is very handy for resculpting things, whether it's an arm that's too thin or a bulge that's too thick. With a little imagination, you'll be amazed at the things you can use it for.

The key to using the tool is to go slowly, and to preselect the area that you want to work with, so that Photoshop performs faster.

1 Hit the m key to select the Marquee tool.

2 Draw a marquee around the part of the image that you want to liquify. Try to keep the selection as small as possible, but leave a little extra room to work.

HOT TIP: The Warp tool will also warp the background. If you use this on a person who is standing in front of something with a strong pattern, you might also have to deal with the background getting warped.

3 Select Filter, Liquify from the menu. The Liquify dialogue will appear.

4 In the Tool Options section of the dialogue, select a low brush pressure, i.e. 10 or less, and a broad brush size. The precise size of the brush will be determined by the nature of whatever you want to reshape.

5 Select the Forward Warp tool from the panel at the left side of the dialogue.

6 Using short to medium strokes, slowly push the edges of the part of the body that you want to reshape with the Forward Warp tool. Don't try to do it all at once – if you do a little at a time, you won't have to start again.

7 Click the OK button to commit your changes and review the result.

8 Repeat steps 3 to 7 as many times as needed.

9 Choose Select, Deselect from the menu.

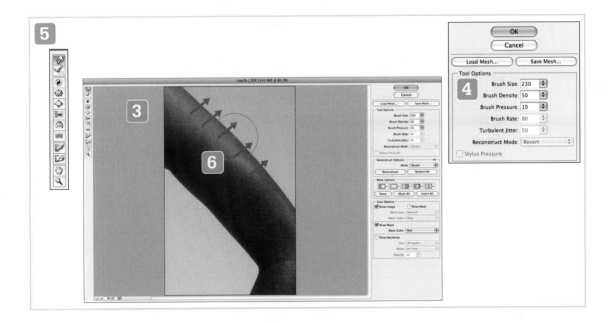

Use the Patch tool

The Patch tool is especially good for fixing moderate size blemishes in a photo. It works by duplicating a selected part of the image and blending the duplicate into its new surroundings. You select a part of the image that you want to fix, then point at an area of the image that you want to duplicate and the Patch tool does the rest.

The Patch tool shares the same button in the Tools panel with the Healing Brush, the Spot Healing Brush and the Red Eye tool.

1 If you have not already done so, duplicate the background layer. We will patch the duplicate.

2 Select the problem area with any selection tool that you like.

3 If the Tools panel is showing either the Spot Healing Brush, the Healing Brush or the Red Eye tool, hold the mouse button down on the button until the fly-out menu appears, and select the Patch tool.

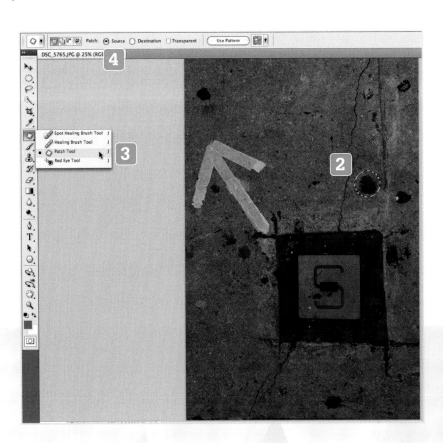

4 In the Tool Options panel, check to see that the circle to the left of Source is filled in. If not, click on the word Source.

5 Place the cursor over the selected area, then press and hold down the mouse button.

6 Drag the cursor away from the selected area. A copy of the selection shape will follow the cursor, and the original selection will change to give a preview of what the patch will look like.

7 When you find an area produces a suitable patch, release the mouse button.

8 Choose Select, Deselect from the menu. The shortcut for that is Command + d [Ctrl + d on the PC].

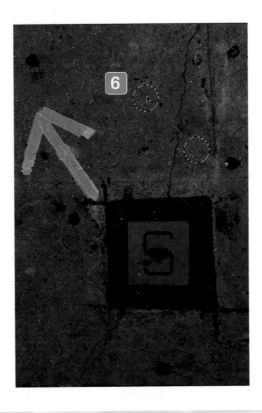

HOT TIP: The Patch tool is the easiest way to fix large areas in an image cleanly. Don't forget to duplicate the background layer before you use it.

Add a blank layer for retouching and rename it

Retouching and editing in Photoshop is very often a form of collage. You are layering lots of pieces to create the final effect. Very often, you will have cases where most of a layer will be transparent, except for a tiny piece that covers up a blemish. By adopting this method, you can come back to the file at any time and revert to the original, redo the retouching or add more.

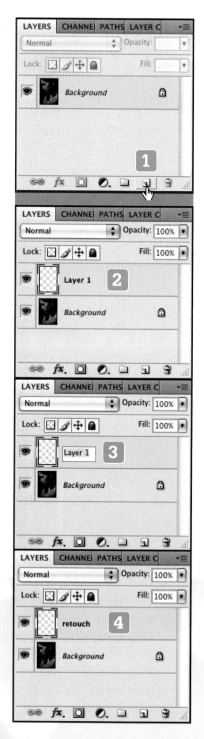

1 Locate the Create a New Layer icon at the bottom of the Layers panel and click on it.

2 Note that a new layer is created. Notice the checkerboard pattern in the layer thumbnail. That's the indication that the layer is transparent.

3 Double-click on the layer's label to begin editing the text. Be sure to double-click on the text, because double-clicking elsewhere on the layer will open up the Layer Properties dialogue.

4 Change the name to retouch and hit the Return key to commit the change.

HOT TIP: Add a New Layer always adds the new layer directly above the currently selected layer.

▶ **SEE ALSO:** For more information on working with layers, see Chapter 4.

Use the Healing Brush

The Healing Brush tool is a mainstay of retouching. It is a relative of the Patch tool and also works by copying and blending. The differences are that instead of using selections, you paint on the effect with the Healing Brush, and it can be painted onto a blank layer, rather than having to use a copy of the background layer.

To use the Healing Brush, you load the brush with a sample first, and then paint over the part that you want to heal. From there, the Healing Brush copies the texture from the area you sampled, and tries to match it to the tone of the area that you're healing.

For this task, we'll start with the file that was used in the last example, which already has a blank layer named retouch waiting for us.

1 Select the Healing Brush tool from the Tools panel. It may be hidden beneath the current tool (e.g. the Patch tool). You can hold down the Shift key and tap the letter j repeatedly until the Healing Brush icon is showing.

2 In the Tool Options panel, click the button immediately to the right of the word Brush to show the Brush Picker.

3 Check to see that the hardness slider is at 100% and hit the Return key to put the Brush Picker away.

4 Check to see that the Mode is normal, and that the circle to the left of Sampled is filled in. If it is not, click on the word Sampled.

5 To the right of the word Sample is a menu: set it to read Current & Below.

6 In the Layers panel, click on the retouch layer to select it.

7 Position the brush over the item that you want to heal, and use the left square bracket ([) key and the right square bracket (])key to set an appropriate size for the brush. The healing brush is now configured.

8 To load the tool with a sample, hold down the Option key [Alt on a PC] and click on an area of skin that has the right texture for the area you're healing. Release the Option key [Alt on a PC] after you release the mouse button.

 HOT TIP: The most common mistake people make when using the Healing brush is forgetting to sample a source first. (Step 8 above.) Photoshop will display an error message if you don't.

6 Check the box that says Sample All Layers.

7 In the Layers panel, click on the retouch layer to select it.

8 Position the brush over the item that you want to heal, and use the left square bracket ([) key and the right square bracket (]) key to set an appropriate size.

9 Click on the area that you want to heal.

? DID YOU KNOW?

If you are using the Spot Healing Brush and try to use the Option key [Alt on the PC] to sample an area, you will see the dialogue shown on page 139.

HOT TIP: The Spot Healing Brush can resize according to pen pressure if you have a pressure-sensitive tablet like the Wacom Intuous.

! ALERT: In order to blend with the surroundings, the Healing Brush and the Spot Healing Brush have to read the area immediately outside of the brush. If your brush passes too close to an adjacent area that is much lighter or much darker than the area you are trying to heal, you can end up with a light streak or a dark streak that bleeds into the area you are working on.

There are several ways to address this problem. The first is to use the smallest brush possible to perform your healing tasks. The larger the brush, the more pronounced this problem can be. A second approach is to make a selection (see Chapter 11) that includes only the area you want to heal. That will tell the Healing Brush or Spot Healing Brush to ignore the area that would bleed into your work area. Don't forget to deselect after you use the brush. Third, try using the Clone Stamp instead of one of the Healing Brushes. If you have a problem where the colours you are cloning are either too dark or too light, you can try using a softer brush (hardness less than 100%) and a lower opacity to build up the cloning until you cover the problem area.

Use the Clone Stamp

The Clone Stamp has the effect of copying and pasting information from one part of your image to another, just as with the healing brushes, but it simply copies without matching the colour and tone the way the healing brushes do. It is best used for tasks like reconstructing parts of pictures.

Like the Healing Brush, you load the Clone Stamp with source material before you apply it. Because the Clone Stamp does not blend, you have to be careful about matching tones, or the cloning will be very obvious.

1 Create a new blank layer for retouching, or click on an existing retouching layer to reuse it.

2 In the Tools panel, click on the Clone Stamp tool. Be sure you've selected the Clone Stamp and not the Pattern Stamp, which is under the same button.

3 In the Options panel, make sure Mode is Normal and Sample is set to Current & Below.

4 Check your opacity. Normally, it should be 100%, but there will be times when you want something lower.

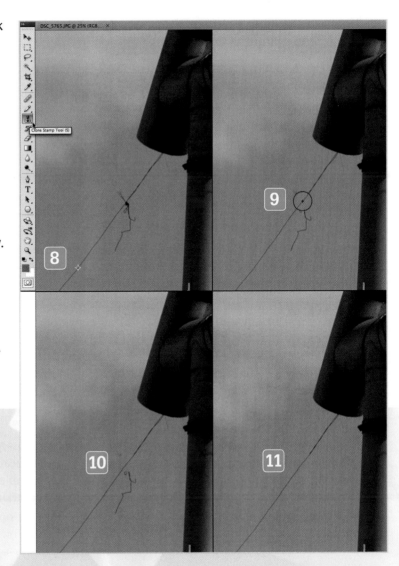

5 Leave the Airbrush option off and keep the Flow at 100%.

6 Position the cursor over the area that you want to cover with your cloning, and select an appropriate brush size using the left square bracket ([) key and the right square bracket (]) key.

7 Move the cursor over the part of the image that you want to copy.

8 Hold down the Option key [Alt on a PC] and click on the area to load the Clone Stamp. The Clone Stamp will now display a preview of what it will stamp inside the brush.

9 Position your brush over the area that you want to clone into, being careful to line up any elements that need to match.

10 Click the mouse button to apply the clone.

11 The remaining bits in the final image were cleaned up with a combination of the Clone Stamp and the Healing Brush.

 HOT TIP: While you generally want a hard edge with the Healing Brush and Spot Healing Brush, it varies with the Clone Stamp. Sometimes, a moderately soft brush will blend better, and make the cloning less conspicuous.

? DID YOU KNOW?

The Clone Stamp and Healing Brush both have a tick box marked Aligned. This is a very useful feature that controls where information is copied from, and can make healing or cloning lots of small areas a much easier task.

Whenever you set a sample point by holding down the Option key [Alt on the PC] and clicking, you are telling the tool where to start copying from as you apply the brush. After you have set the sample point, and as soon as you hold down the mouse button somewhere in the image, a little crosshair will appear where you set the sample point, indicating where the brush is getting the information that it is copying. As you drag the mouse across the image, that crosshair will move in a path that parallels the movement of the brush. This behaviour is the same for the first stroke you make, whether Aligned is ticked or not.

Aligned takes effect whenever you make the second and subsequent strokes. If Aligned is turned on, the brush will move the starting point to a new location each time you start a new stroke, based on where you moved the brush. For example, you can see that sampling at point (A) moves the source mark each time in (B), (C) and (D).

If Aligned is turned off, the brush continues to copy from the original starting point. The sampling point at (E) stays fixed as you heal points (F) and (G).

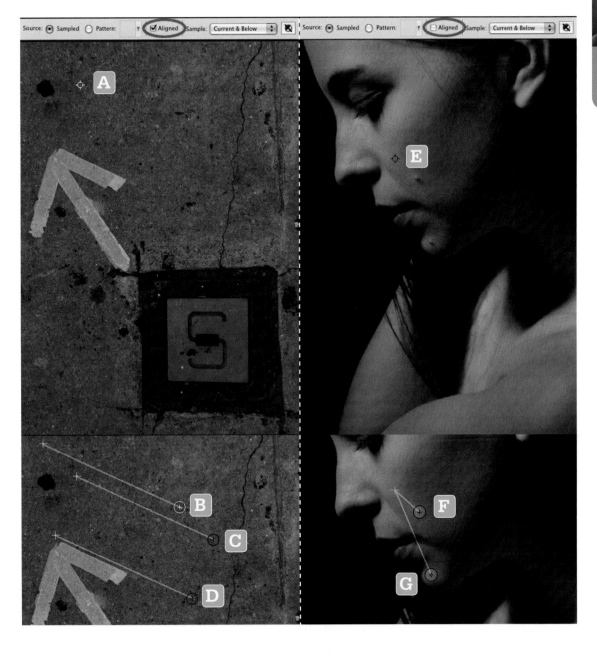

10 Adjust tones and colours in Photoshop

Make a curves adjustment layer from scratch

Sometimes, the black point and white point are exactly where they need to be, but certain tones in the image could still use some additional contrast. Rather than use a preset, it's a straightforward matter to make your own custom contrast curve.

1 If you have more than one layer in your file, click on the top-most layer to select it.

2 Make sure the Adjustments panel is visible. If the Adjustments panel is not showing the controls to add an adjustment, click on the left-facing arrow at the bottom of the panel.

3 In the Adjustments panel, locate the icon to add a curves adjustment layer and click on it. The new curves layer will be added, and the panel will change to display the adjustment curve.

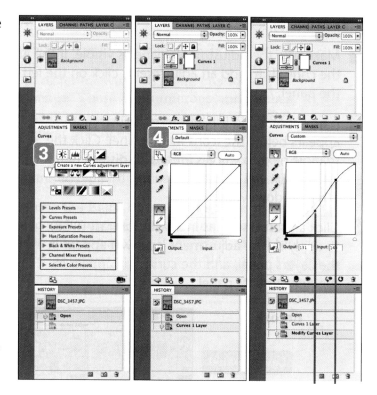

4 Click on the finger icon on the left side of the Adjustments panel. The button will darken when it is switched on.

5 Position the cursor over an area in the image where you think the tones should be darker. The cursor will look like an eyedropper as soon as it moves over the image.

6 Press and hold down the mouse button. The cursor will change shape, and a point will appear on the curve representing the tone you are clicking on.

7 Continue holding down the mouse button, and drag downwards gradually to darken that tone. The point on the curve will move, and the image will darken. If you go too far, move the mouse back upwards. Release the mouse button when the tone is sufficiently darkened.

8 Locate a medium or somewhat light tone that should be even lighter – one that is lighter than the tone you just darkened.

9 Hold the mouse button down on that area, and drag upwards to lighten. The relevant point on the curve will move upwards. You can drag back downwards if you go too far. Release the mouse button when the tone is sufficiently lightened.

Before

After

 HOT TIP: In some cases you'll use a combination of setting the white and black points in conjunction with click and drag adjustments to the moderate tones. It's best to do the white and black point adjustments first.

Adjust the black point and white point in an image

Preset curves are useful, but sometimes it's more effective to target the tones we're interested in and make our own curves. In situations where the lighting or the exposure have made the blacks in an image weak, changing the black point can dramatically improve the image by adding weight. Similarly, dull highlights can be improved by moving the white point. Either of these moves will also increase the contrast in your image.

1 If you have more than one layer in your file, click on the top-most layer to select it.

2 Make sure the Adjustments panel is visible and click the button to add a curves layer. If the Adjustments panel is not showing the controls to add an adjustment, click on the left-facing arrow at the bottom of the panel.

3 Click and drag the black point slider to the right to add density to the blacks in the image. Careful! Moving this slider too much to the right will 'block up' the shadows and make images lose shadow detail.

4 Click and drag the white point slider to the left to make the highlight tones brighter. Note that moving the white pointer too far to the left will 'blow out' your highlights.

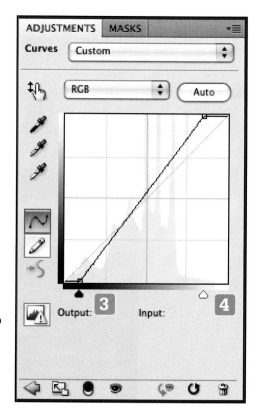

 HOT TIP: For a preview of how much of your image is being affected by these sliders, hold down the Option key before you click and drag the slider, and keep holding the Option key as you drag. The screen will show you what parts of the image are either blocked up or blown out as you move the slider.

Adjust saturation

Saturation is the relative purity of the colours in an image. There will be times when you will want to increase or decrease the amount of saturation in an image simply for aesthetic reasons. In the example here, we will reduce saturation to compensate for the boost in saturation that has occurred when we added a curves adjustment to an image.

This example uses an alternative approach to adding an adjustment layer: we will use the Fill or Adjustment Layer menu on the Layers panel, instead of the buttons in the Adjustment panel. Doing it this way saves a step or two.

1 Click on the top-most layer in your image.

2 Hold the mouse button down on the new fill or adjustment layer icon at the bottom centre of the layer panel. A menu will appear.

3 Choose Hue/Saturation from the list. A hue/saturation layer will be added to the Layers panel and the Adjustments panel will display the hue/saturation controls.

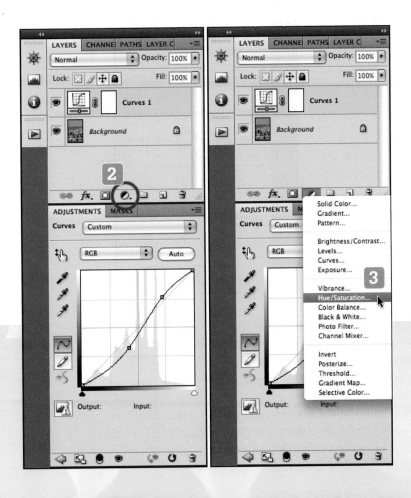

4 Move the saturation slider to the left to decrease saturation to a point that looks acceptable.

5 Click the eyeball icon at the bottom of the Adjustments panel off and on a few times to compare the look with and without the effect. In this case, you're looking for a subtle but detectable effect.

6 Optional: re-adjust the saturation slider as needed, and toggle the layer on and off with the eyeball until you like the effect that you are seeing.

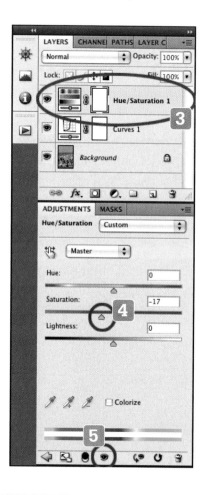

 HOT TIP: A Saturation adjustment is best when compensating for the saturation shifts that can occur with a Curves adjustment, but the Vibrance adjustment works better in other applications. The Vibrance adjustment protects skin tones and highly saturated colours from being over saturated.

Target a colour and adjust hue and saturation

Using the hues adjustment, you can shift all of the colours in your image, or just some of them. If most of the colours in your photo look good, but that lipstick isn't red enough, the hues adjustment will do the trick for you.

1 In the Layers panel, click the top-most layer.

2 Hold the mouse button down on the black and white circular icon at the bottom of the Layers panel to display the menu.

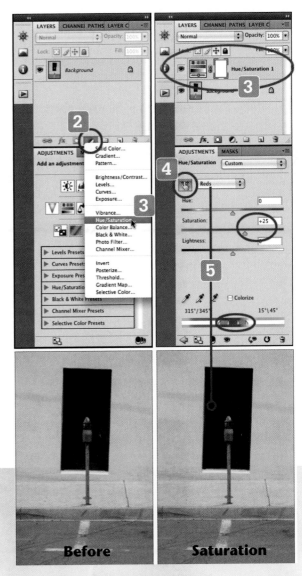

Before **Saturation**

3 Click on Hue/Saturation in the menu. A new hue/saturation layer will be added to the Layers panel, and the Adjustments panel will display the Hue/Saturation controls.

4 Click the finger icon in the upper left corner of the Adjustments panel. The button will darken slightly when it is switched on.

5 Place the cursor over the colour in the image that you would like to change, and hold the mouse button down on it. The Adjustments panel will update, showing the colours you have targeted.

6 Keep holding the mouse button down, and drag to the right to increase saturation or to the left to decrease saturation.

7 Release the mouse button when you have a satisfactory result.

8 Move the hue slider to locate a colour that makes the image look more interesting.

9 Optional: if you want to redo the saturation or the hue, simply drag the appropriate slider to adjust the setting.

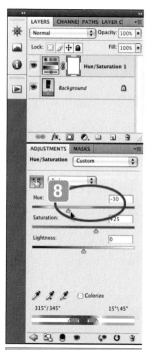

Hue

Adjust vibrance

The vibrance control in Photoshop can be thought of as a smart saturation control. It increases or decreases saturation, but protects skin tones, which don't look good when they become oversaturated. You can use the vibrance adjustment on any type of image, but it's most likely to distinguish itself with images that contain skin tones.

Sometimes, a small boost in saturation is still useful, so the vibrance adjustment layer has a slider for saturation as well.

1 Select the top-most layer in your image.

2 Make sure the Adjustments panel is visible. If the Adjustments panel is not showing the controls to add an adjustment, click on the left-facing arrow at the bottom of the panel.

3 Click the Vibrance button. A new adjustment layer for vibrance will appear in the layers panel, and the Adjustments panel will display the vibrance controls.

4 In the Adjustments panel, move the Vibrance slider until you achieve the desired effect.

5 Optional: in a situation where the skin tones in your original image are either too saturated or too weak, you might adjust the overall saturation to compensate for the skin, then readjust vibrance as needed.

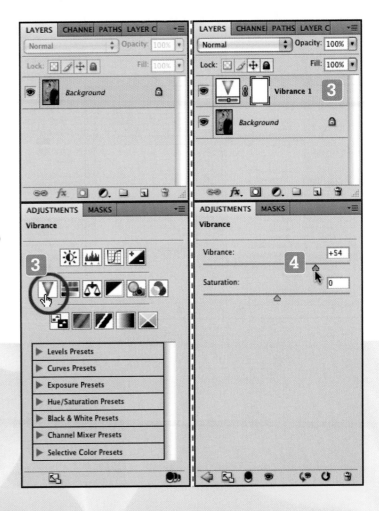

Adjust colour and contrast with curves using the Auto button

The Auto button in the curves dialogue has a number of preset routines for improving the appearance of an image. It's no panacea, but the options are useful.

1 Click on the top-most layer in your image.

2 Choose curves from the adjustment layer menu at the bottom of the Layers panel.

3 A new curves adjustment layer will appear, and the Adjustments panel will display the curves controls.

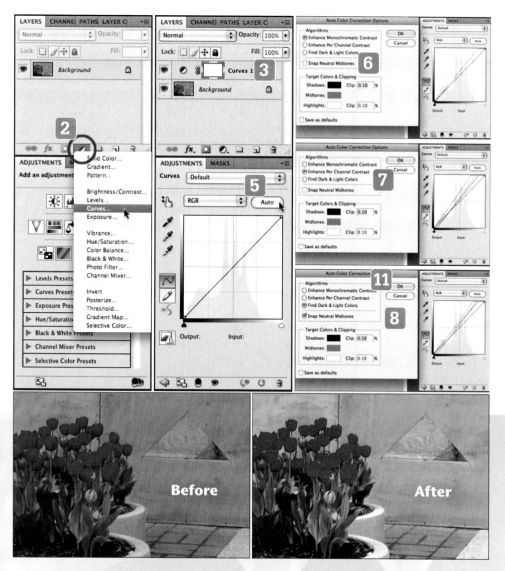

4 Hold down the Option key [Alt on the PC] on your keyboard.

5 While continuing to hold the Option key [Alt on the PC], click the Auto button in the Adjustments panel. The Auto Color Correction Options dialogue will appear.

6 Leave the box next to Snap Neutral Midtones unticked.

7 Click on the circle next to each of the three options in the Algorithms section, noting which looks better.

8 Tick the box next to Snap Neutral Midtones.

9 Click on the circle next to each of the three options in the Algorithms section, noting which looks better.

10 Compare the best of the results with Snap Neutral Midtones ticked against those with Snap Neutral Midtones unticked to determine the best course of auto correction.

11 Click the OK button.

? DID YOU KNOW?

If you look at the display in the Adjustments panel as you apply an auto colour correction, you may notice that separate red, green and blue lines move to different positions in the graph as you try different algorithms. This is a direct indication of how Photoshop is mixing the colours in your image.

Digital colour works on the principle that equal amounts of red, green and blue add up, either to white or a neutral shade of grey. All other colours result from mixing unequal amounts of these three optical primaries. This is known as additive colour, and it is the way colour works whenever we are blending coloured light.

When we work with pigments, inks and dyes, we are dealing in subtractive colour, which might be more familiar to anyone who has mixed paint. In subtractive colour, cyan, magenta and yellow add up to a muddy grey, and pure black is added to compensate for the impurities of pigment.

In Photoshop, each channel is a map that indicates how much red, green or blue is assigned to each pixel. The curves adjustment essentially alters the contours of these maps, and thereby alters the resulting colours we see. The curves feature allows us to alter the colour of the image by changing the contours of each channel in unequal amounts.

The channels in the curves adjustment work on the principle of opposing (complementary) colour. When two opposing colours are added together in equal proportions, you get a neutral grey or white. The opposing colours of red, green and blue are cyan, magenta and yellow, respectively. Thus our three colour channels are really red/cyan, green/magenta and blue/yellow, which is the key to how Photoshop can do colour correction. For example, if your image is too yellow, you can add blue to neutralise it. If it is too red, you can add cyan, and so forth.

Armed with this knowledge, you could manually correct or adjust your colours, but the auto options offer six pre-fabricated recipes that often do a great job with a minimum of effort. Three of the six possible algorithms are shown in the screenshot (7).

Colourise a black and white image

Adding monochromatic colour back to a black and white image can be a way of creating artistic images. Certain colours (such as sepia) can immediately make a photo look more 'retro', while others can add drama or emotional impact.

In this example, we'll use the Hue/Saturation adjustment to colourise the image that we converted to black and white in the previous example. A cyanotype effect is added to a black and white image by adding a hue/saturation layer. The effect is then moderated by reducing the layer's opacity to 73%.

1 Click on the top-most layer in your image to select it.

2 In the Layers panel, choose Hue/Saturation from the menu at the bottom of the panel.

3 A new hue/saturation adjustment layer will appear, and the Adjustments panel will display the Hue/Saturation controls.

4 In the Adjustments panel, do one of the following:

- Choose Cyanotype from the menu (A). Note that the box next to Colorize becomes ticked.
- Choose Sepia from the menu. Note that the box next to Colorize becomes ticked.

5 Optional: decrease the intensity of the effect by reducing the opacity of the hue/saturation layer as follows:

- In the Layers panel, click on the triangle next to the opacity percentage. A slider will appear (B).
- Drag the slider to adjust the opacity of the layer. The percentage will change.
- Release the slider when you are happy with the reduction of the effect.

 HOT TIP: If you experiment with the hue/saturation layer, you'll discover that you can make a colourised image without converting to black and white first. However, if you do it that way, you'll have far less control over the tones in the colourised version.

Cyanotype and Sepia are preset recipes, but you don't have to keep to those colours. You can use any hue or saturation settings you like. Be sure to tick the box next to Colorize for the effect.

Alternatively, you can add a photo filter layer instead of a hue/saturation layer. The photo filter layer works in a similar way, and features a number of preset filter colours with a density slider to control the effect.

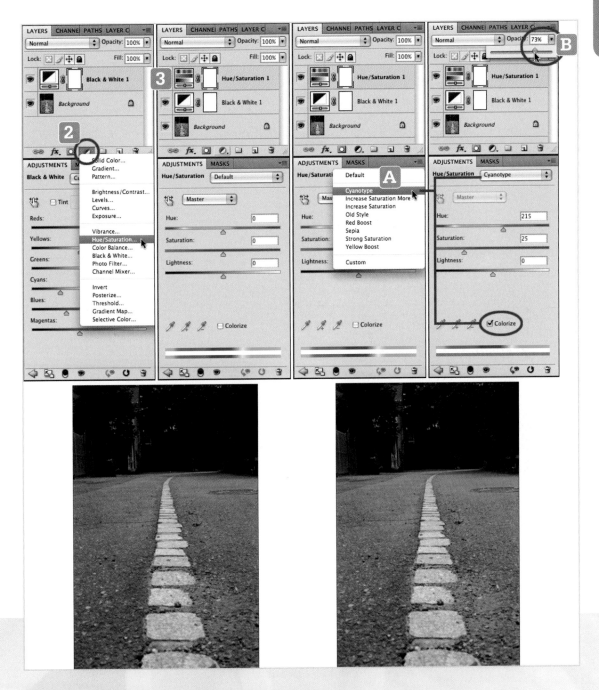

11 Make selections

Introduction

Selections are at the core of Photoshop's power. They can be used to constrain painting, filling and deleting, and they can also be used as the basis for creating masks. The sophistication of selections comes from the fact that they can be combined and modified, and that they can partially select pixels to produce soft-edged effects. Furthermore, selections can be translated into masks and alpha channels, which can in turn be translated back into selections. We will cover selections extensively in this chapter.

Select using the Rectangular Marquee and use Deselect

The Rectangular Marquee tool is a tool that you will use repeatedly to make simple selections.

1 Start by opening a blank document: Select File, New… from the menu bar, choose a size such as the Photo preset, and click OK.

2 In the Tools panel, press and hold the mouse button down on the Marquee tool button to reveal the fly-out menu.

3 If a small square does not appear next to the Rectangular Marquee tool, select it from the menu.

4 Put the cursor over the canvas, hold down the mouse button and drag out a rectangular shape, then release the mouse button. You will see an outline of marching ants.

5 Select Edit, Fill from the menu bar, and fill the selection with any colour you like, as long as it does not match the canvas colour. Notice that the marching ants (the selection) are still in place.

6 Choose Select, Deselect from the menu to release the selection, or use the keyboard shortcut: Command + d [Ctrl + d on the PC].

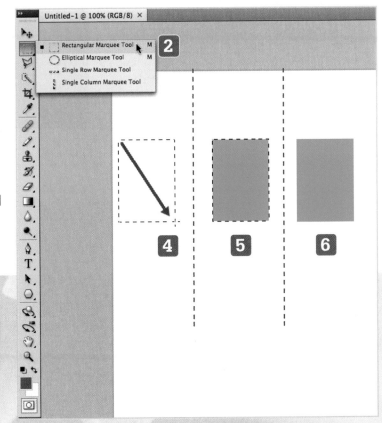

HOT TIP: Use the Shift key to make a perfect square.

Select using the Elliptical Marquee

The Elliptical Marquee tool is used for making curved selections. We'll use it to demonstrate a feature of both the Elliptical and Rectangular Marquee tools: selecting from the centre outwards.

1 Hold down the shift key and tap the m key until the Elliptical Marquee tool is active.

2 Position the cursor near the centre of the shape that you created in the previous task.

3 Hold down the Option key [Alt on the PC], and press and hold down the mouse button.

4 While continuing to hold the Option [Alt] key, drag outwards and notice how the shape forms.

5 Release the mouse button and the Option [Alt] key.

6 Select Edit, Fill ... from the menu bar, choose white for the colour, and click OK.

7 Use Command + d [Ctrl + d on the PC] to deselect.

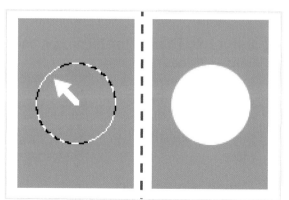

 HOT TIP: Use the Shift key to make a perfect circle. You can draw circles and squares from the centre by holding down both Shift and Option [Alt on the PC].

Select with the Lasso

The lasso is a free-form selection tool that is best for loose, irregular selections.

1 Select the Lasso tool from the Tools panel, noting that the keyboard shortcut is the l key.

2 In the Tool Options panel, be sure that the selection mode is set to New selection.

3 Position the Lasso tool over the canvas, press the mouse button down and drag an arc, releasing the mouse button before the cursor comes back to the starting point. Marching ants will indicate your selection.

4 Notice that the Lasso connected the start and end points with a straight line.

5 Notice that the Refine Edge ... button is now active.

6 Hit Command + d [Ctrl + d on the PC] to deselect.

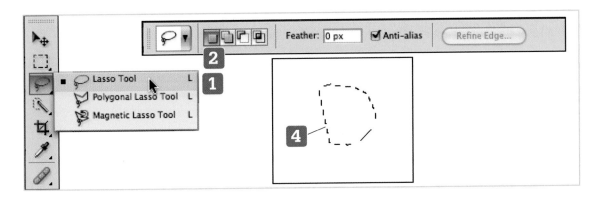

 HOT TIP: The Lasso and Marquee tools all have a Feather setting. You can use this to make the edges of the selection softer, but it's hard to previsualise the effect. It is often better to leave the Feather set to zero, then use the Refine Edge feature to soften the selection. We will cover the Refine Edge feature later in this chapter.

Select with the Polygonal Lasso and reposition a selection

The Polygonal Lasso makes a selection by connecting the points where you click on the canvas. It is still best for loose selections, but you can get fairly precise with it by clicking enough points.

1 Select the Polygonal Lasso tool from the Tools panel. You can do that quickly by holding down the Shift key and tapping the I key until the tool appears.

2 Check again to be sure that the selection mode is set to New selection.

3 Click on the canvas in several places to create a shape.

4 Note that when you bring the cursor back to the starting point, the cursor will change to indicate that it is ready to close the shape.

5 Click the mouse button to close the shape. Marching ants will appear.

6 Move the cursor inside the selection and notice that it changes to a new shape.

7 Press and hold the mouse button, then drag the selection to a new location and release the mouse button.

8 Use Select, Deselect to release the selection.

The screenshot shows the process of selecting with the Polygonal Lasso tool and then repositioning the selection.

? DID YOU KNOW?

The Marquee, Lasso, Quick Selection and Magic Wand tools all allow you to reposition a selection by clicking and dragging it. Make sure you click inside the selection or you're likely to start a new selection. If you drag a selection with the Move tool instead of one of the above, it will tear pixels out of the active layer and reposition them.

HOT TIP: If your shape starts to get out of hand, you can hit the Escape key to cancel what you have done so far and start again.

Select with the Magnetic Lasso

The Magnetic Lasso is a tracing tool that reads contrast to create a selection. It is especially helpful for selecting the outlines of shapes that have a well-defined edge.

1 Select the Magnetic Lasso tool from the Tools panel.

2 In the Options panel, set the Width to 20 px, Contrast to 40% and Frequency to 80.

3 Place the crosshair of the brush near the edge that you wish to select.

4 Press and hold down the mouse button, and slowly guide the brush along the edge.

5 Notice that selection points are being laid down. The spacing of those points depends on the frequency setting you choose.

6 When the cursor reaches your starting point, it will change shape to indicate that it is ready to close the shape.

7 Click the mouse button to complete the shape.

8 Inspect the selection. If you are not satisfied, use Select, Deselect and try dragging more precisely, or change the settings and try again.

9 Leave your final selection in place. We'll use it for the next task.

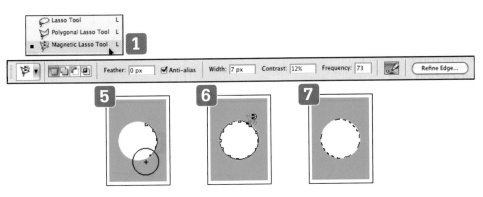

HOT TIP: You can temporarily switch the Magnetic Lasso to a Polygonal Lasso or the plain Lasso tool by holding down the Option key [Alt on the PC]. If you simply click, it operates as a Polygonal Lasso. If you press the mouse button down and drag, it operates as a plain Lasso.

? DID YOU KNOW?
You can change the width of the Lasso Tool with the bracket keys. The more clearly the shape stands out against the background and the more well defined its edges, the greater the width and contrast settings you can use. The less distinct the shape, the more precisely you will need to trace.

Use Select Inverse

Select Inverse makes a selection out of what was previously unselected, and deselects what was previously selected. This is particularly useful, because sometimes it's easier to select what you don't want, and then select the inverse.

1 If you don't have a selection on the canvas, make a selection with any tool.

2 Notice the marching ants around the edge of your selection.

3 Choose Select, Inverse from the menu.

4 Notice that there are now marching ants around the edge of the area you selected before and around the edge of the canvas.

5 Select Edit, Fill … from the menu, choose white for the fill colour, and click OK.

6 Select Edit, Fade Fill … from the menu, set the opacity to 50%, and click OK.

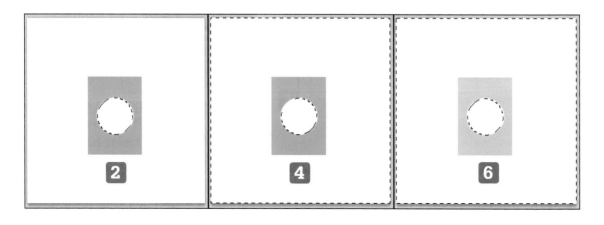

HOT TIP: The keyboard shortcut for Select Inverse is Shift + Command + i [Shift + Ctrl + i on the PC].

Use the Refine Edge command

Refine Edge allows you to fine-tune and feather the edge of your selections in various ways.

1 Make a selection using any selection tool.

2 Notice that the Refine Edge ... button in the Tool Options panel has become active.

3 Click Refine Edge ... A dialogue box will appear.

4 Click on the preview on black icon, the third icon from the left near the bottom of the dialogue.

5 Experiment with the Radius slider.

6 Set the radius to 30 and experiment with the Contrast slider to see its effect.

7 Set the radius back to zero and move the Smooth slider to the right to see its effect.

8 Experiment with the Feather slider to see its effect.

9 With the Feather slider set to at least 1 px, experiment with the Contract/Expand slider.

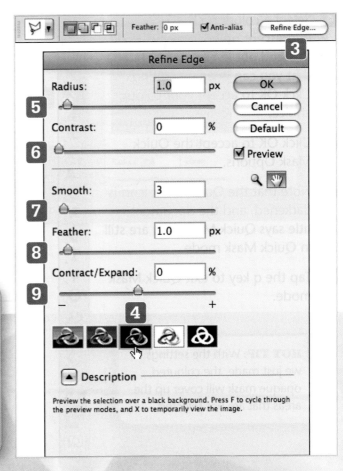

HOT TIP: The black background will make the selection obvious in most cases. You can switch among the other preview modes by repeatedly tapping the f key. You can also toggle the preview on and off with the p key.

6 If the foreground colour is not black, tap the d key to set the default colours. Even though you will be painting in black and white, your painting will appear in whatever colour you selected for your Quick Mask preference.

7 Paint in black along the left edge of the image to harden it, and place a black dot in the white area.

8 Tap the x key to swap foreground and background colours.

9 Paint in white in an area adjacent to the part that is already white, and add some white to change the shape of the dot in the middle.

10 Tap the q key to exit Quick Mask mode. Your selection will appear as marching ants.

11 Use Edit, Fill … from the menu to colour your selection, then use Select, Deselect to dismiss the marching ants.

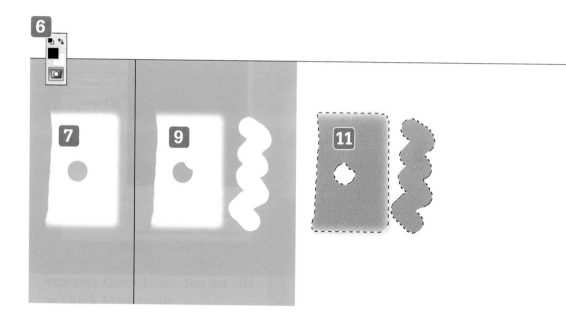

HOT TIP: If it takes more than a few seconds to create your selection and there is any chance that you might need to use that selection in the future, choose Select, Save Selection… from the menu bar to store the selection, and Select, Load Selection… to re-use it in the future.

Create a new selection with Quick Mask

The Quick Mask tool can easily be used to paint a selection. There is a slight twist to using it effectively.

1 Tap the q key to enter Quick Mask mode.

2 Select the Brush tool, and check to see that the foreground colour is black.

3 If the foreground colour is not black tap the d key.

4 Vary the brush size and hardness as needed to paint in black over the part of the image that you want to select. Don't worry if you overshoot. You can fix that shortly.

5 Hit Command + i [Ctrl + i on the PC] to invert. (Note this is the shortcut for Image, Adjustments, Invert, which is very different from Select, Inverse.)

6 With black as the foreground colour, paint in any areas that you do not want selected.

7 Tap the x key so that white is the foreground colour, and paint to remove any colour from areas that you do want to select.

8 When your Quick Mask is complete, tap the q key to exit, and note the marching ants.

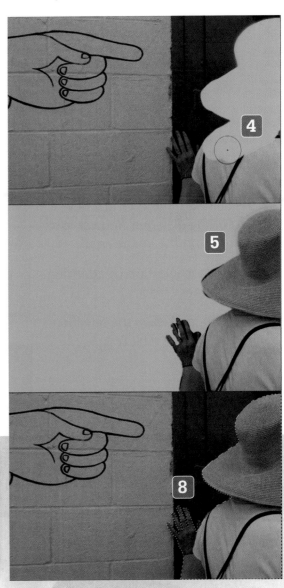

HOT TIP: As long as you don't release the selection, you can return to Quick Mask mode and continue refining the selection. Don't forget that you can use zoom to get in close. You can also paint at less than 100% opacity to build up coverage.

Select by Color Range

Did you ever want to select just the sky in a photo, or everything that wasn't the sky? Or perhaps you want to select the skin tones. This is the tool to do just that.

1 Choose Select, Color Range ... from the menu bar. The Color Range dialogue will appear.

2 Leave Select set to Sampled Colors.

3 Leave the box next to Localized Color Clusters unticked.

4 Start with a fuzziness of 30 or so.

5 Make sure the box next to Invert is left unticked.

6 Near the bottom of the dialogue, make sure the circle next to Image is filled in.

7 Set the Selection Preview to Quick Mask.

8 In the dialogue box, click on a colour that you want to select. You will see the preview update.

9 To add more colours, hold down the Shift key and click in a new part of the dialogue. You can also shift-click in the image area.

10 Refine your selection by adjusting the Fuzziness slider.

11 Click OK, and leave the selection in place for the next task.

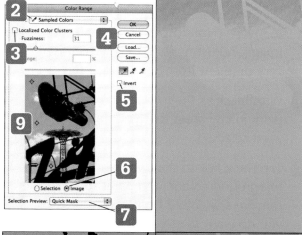

 HOT TIP: The example above selects all the sky elements. If you want to select everything that's not sky, you can tick the box next to Invert before you click the OK button.

Save a selection

Once you've spent more than a minute or two creating a complex selection, you can appreciate how useful it might be to be able to save and reuse it.

This task assumes you have the selection from the previous example. If you don't, that's OK. Just create any selection to start.

1 Choose Select, Save Selection ... from the menu bar. The Save Selection dialogue will appear.

2 Enter a name for your selection.

3 Leave Document and Channel as shown, and leave the circle next to New Channel filled in.

4 Click OK.

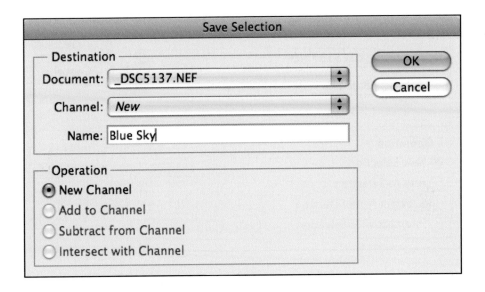

? **DID YOU KNOW?**

This dialogue has a number of advanced features. You can use it to create selections in other documents, and to replace other saved selections, alpha channels or even masks in your file.

Load a selection

Saved selections are part of your file and can be loaded and reused any time.

If you have a selection active (if you see marching ants), use Select, Deselect from the menu bar before you start. You don't have to deselect to load a selection; we are doing this so that the effect of the operation is clear.

1 Choose Select, Load Selection … from the menu bar. The Load Selection dialogue will appear.

2 If you have saved more than one selection, use the Channel menu to choose which selection to load.

3 Click OK to load the selection.

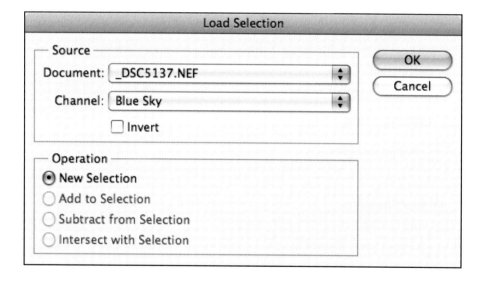

HOT TIP: Because there was no selection active before we invoked the dialogue, the only operation available was New Selection. Note that you can invert (as in Select Inverse) the selection that you are loading. If you started with a selection, you can add, subtract and intersect the saved selection with the active selection, just like the selection tools described at the beginning of this chapter.

12 Sharpening

13 Saving and exporting files from Photoshop and Adobe Bridge

Introduction

Photoshop is a great translator of file formats. While the task of saving files is somewhat straightforward, there are some places where you can get into trouble. We'll address those in this chapter.

Whenever we want to save a file for the Internet, we have to deal with sizing it so that it fits the screen properly, and so that it will download as fast as possible. We will look at two methods of doing that.

Finally, we can use Adobe Bridge to grab several images at once and either make a PDF file or a Web gallery without having to actually visit Photoshop.

Open a file from Adobe Bridge

We're going to open a file in the most rudimentary way here, because this chapter is about saving and exporting. For more detailed information on opening different file formats in Photoshop and Camera Raw, see Chapter 8.

1 Browse a folder containing images in Adobe Bridge.

2 Double-click on the image that you want to open.

3 If the image was a JPEG, TIFF or PSD file, it will open directly into Photoshop.

4 If the image is a raw file, it will open in Camera Raw. Don't concern yourself with any adjustments, just click Open Image and continue into Photoshop.

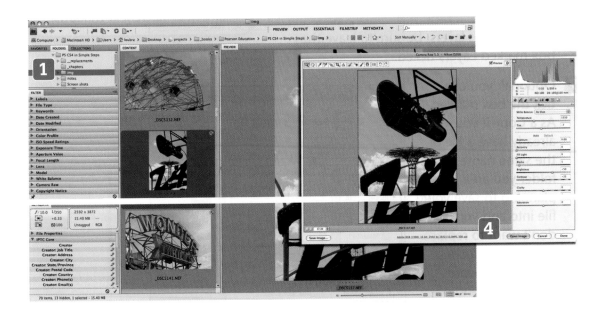

? DID YOU KNOW?

It is possible to set a preference in Photoshop so that even JPEG and TIFF files open in Camera Raw when you double-click on them in Adobe Bridge.

Make a PDF using Adobe Bridge

Adobe Bridge makes simple work of selecting a group of images and combining them into a PDF file. The PDF can even be set so that upon opening, it expands to full screen mode, and plays the images as a slideshow.

1 Using Favorites, Folders or Collections, browse a group of images in Adobe Bridge.

2 Change the workspace to Output by using either the workspace menu or a workspace button. The Output panel will appear.

3 Select one or more of the thumbnails in the Content panel. Only the selected thumbnails will be placed into your PDF file.

4 In the Output panel, click the PDF icon.

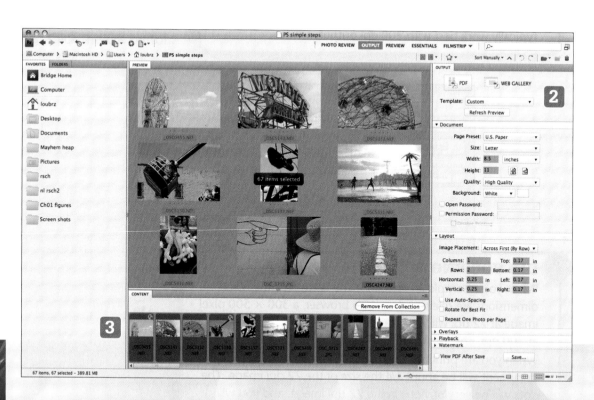

5 If the Document section is collapsed, click the triangle next to the word Document to expand the section.

6 Specify the paper size, orientation, image quality and background colour in the Document section of the Output panel.

7 If the Layout section is collapsed, click the triangle next to the word Layout to expand the section.

8 Use the controls in the Layout section of the panel to specify how images will be arranged inside the PDF document.

9 Optional: if you want to review the PDF as soon as you save it, make sure that the box marked View PDF After Save is ticked. Use the triangle next to the word Playback to show the playback options and make the PDF automatically play a slide show when it is opened.

10 Click the button marked Save ... A Save As dialogue will appear.

11 Use the controls in the Save As dialogue to name your PDF and specify where it will be saved.

12 Click Save.

? DID YOU KNOW?

To select images in the Content panel you need to click on at least one image in the Content panel to select it. The image will appear in the Preview panel.

To select more images to add to your PDF, do one of the following:

- Use Command + a (Ctrl + a in the PC) to select all of the images in the content panel.
- Hold down the Shift key and click another thumbnail in the Content panel. This will select all of the images, inclusive, between the first and second image.
- While holding down the Command [Ctrl in the PC] key, click each additional image that you want to select until you have selected all of the images that you want to use.

Saving to disk and uploading

To save to disk:

1 In the Create Gallery section, click the circle (radio button) next to Save to Disk. A dot will appear inside it when selected.

2 Click the button marked Browse A dialogue box will appear, allowing you to select where the Web gallery will be created on your hard drive.

3 Click Choose to set the location and finish specifying where the gallery will be created.

4 Click the Save button to build the Web gallery.

To upload:

1 In the Create Gallery section, click the circle (radio button) next to Upload. A dot will appear inside it when selected.

2 Enter the FTP server, user name and password for your Web server.

3 Leave the Remember Password option unticked. If you tick it, your password will be stored as plain text, i.e. in an unsecure state.

4 In the Folder field, enter the full path to the folder that will contain your Web gallery (e.g. /web/mystuff/loubenjamin.com/coney_island).

5 Click the Upload button to begin the FTP transfer. Dialogues will tell you the status of the upload process.

HOT TIP: If you save your Web gallery to disk, you'll be able to edit and make additional changes to your gallery (such as incorporating it into a larger website that contains more than one gallery) before uploading it to your Web server. Saving to disk also allows you to archive a copy of the gallery offline. If you upload directly, the Web server will contain your only copy of the gallery.

You'll need a separate FTP utility to upload your saved Web gallery. Whether you use the Upload option in Adobe Bridge or a separate FTP utility, you'll need to know how to log in to your Web server, and where to place the files.

While the Upload feature in Adobe Bridge offers one-stop shopping, many stand-alone FTP utilities offer more features and faster performance.

14 Printing

Introduction

When you print, your first concern is setting the proper print size and resolution. Depending upon your needs, you may either resize or resample the image. Sharpening is a matter of personal preference, and is best applied after the image is sized, if at all. The next consideration is the colour profile and bit depth you wish to work with. If you let Photoshop manage the colours, you can work with wide-gamut colour spaces like Adobe RGB and Prophoto RGB, but if you let the printer manage the colours, most will only give good results with sRGB.

There are several issues in printing that will vary, depending upon the type of print that you wish to make, the paper that you use, and the make and model of your printer. Photoshop directly controls only half of the printing process; the printer driver controls the rest. The examples in this chapter will feature the popular Epson 2880 printer drivers. Because printer drivers can look very different by make and model, your printer driver's screens may look different, but the principles and often the language used will be exactly the same.

Flatten for printing only

If your file is large and has a lot of layers, you might consider flattening and saving it as a copy specifically for printing purposes. The flattened file will open and print faster. If you flatten your only copy just prior to printing, it's a good idea to undo the flattening immediately afterwards.

1 Make the Layers panel visible and hold the mouse button down on the menu icon in the upper right corner of the panel.

2 Select Flatten Image from the menu. Your file is now flattened.

3 To save as a copy, choose File, Save As … from the menu. The Save As dialogue will appear. Be sure that As a Copy and Embed Color Profile are ticked, then click Save.

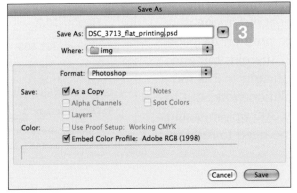

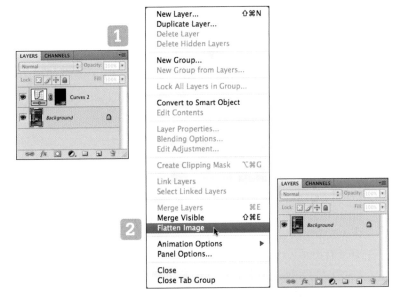

HOT TIP: You can also flatten a file by choosing Layer, Flatten Image from the menu bar.

Resize for printing

Resizing is a non-destructive way of printing at a different size. It works by telling the printer to increase or decrease the size of the dots that it prints.

1 Choose Image, Image Size … from the menu bar. The Image Size dialogue will appear.

2 Make sure the box marked Resample Image near the bottom of the dialogue is not ticked.

3 Enter a width or a height that best fits the paper you will be printing on.

4 Note the resolution. If the number falls well below 240 pixels/inch, you should consider resampling.

5 Click OK.

6 If you plan to regularly print at this size, save your file, and these dimensions will be stored in the file.

Here the Image Size dialogue is configured for resizing only. A 10-megapixel image is resized to print on A4 paper with 1/2" margins top and bottom (height = 272 mm). The resolution works out to well over 300 ppi, meaning there is no need to resample.

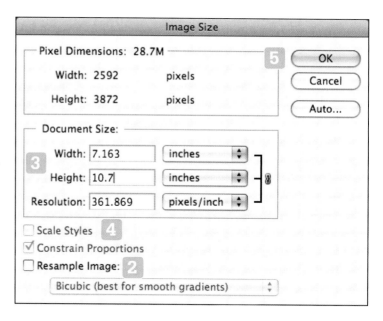

Resample for printing

Resampling is a calculation that alters your file, so it is best done on a copy of your image. For printing, you only need to resample when you want to make your image larger and keep the resolution above 240 ppi.

1 Choose Image, Image Size... from the menu bar. The Image Size dialogue will appear.

2 Start with the box next to Resample Image unticked.

3 Enter an appropriate width or height; the other dimension will be calculated for you.

4 If the resolution is at or above 240 ppi, there is no need to resample – you can click the Cancel button.

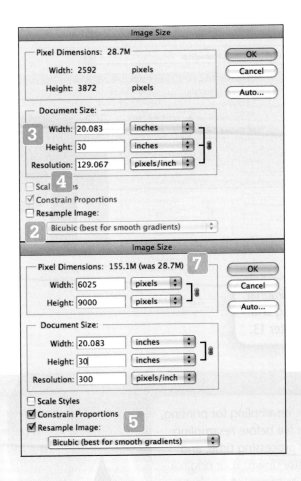

Select media type, colour mode and bits/channel

The Media Type setting controls how much ink is put down on the paper. With the Color menu, you can choose between colour and black and white printing. The 16-bit option allows you to keep your file in 16 bits straight through to the printer. Older printer drivers only handled 8 bits/Channel.

1 Choose a media type setting that best describes the paper you are using. If you are not using Epson paper, you may have to guess.

2 Choose whether to print in colour.

3 If your file is a 16-bit file, click the box next to 16 bit/Channel so that it is ticked.

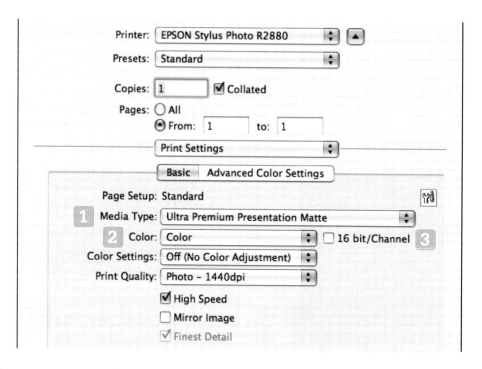

HOT TIP: If you're printing on another manufacturer's paper with an Epson printer it may not be obvious which Media Type setting to choose. If you have questions, it is worth checking with the paper manufacturer for its recommendation.

Turn off colour adjustment and set print quality

It is important to turn off the print driver's colour settings because these will interfere with Photoshop's colour instructions.

1 Use the Color Settings menu to turn off the colour adjustment.

2 If the profile you selected specifies a print quality, be sure to choose a print quality setting that matches.

3 If you are having problems with horizontal streaks in your prints, try turning off the tick mark next to High Speed.

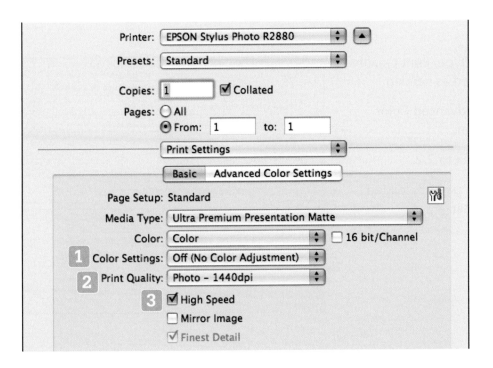

HOT TIP: If your prints are coming out with a magenta colour cast, check to make sure that Color Settings are turned off.

Print in black and white

One of the strengths of the Epson printers featuring the K3 ink system is their ability to print neutral black and white images. This example uses the Epson R2880 printer, however there are other printers that have similar features and capabilities.

For best results, you can use a black and white adjustment layer to convert your colour images, and then print with Color set to Grayscale. You can also print from a grayscale scan of a black and white negative.

1 Select File, Print from the menu bar, and set up the page layout and colour management sections of the first dialogue as before.

2 Click the OK button to move on to the printer driver.

3 In the Epson 2880 driver, go to the Print Settings page and change the Color menu to Grayscale.

4 Adjust Media Type, Print Quality and High Speed as needed.

5 Click on the Advanced Color Settings button.

6 Set the Gamma to 2.2.

7 Make sure the paper is loaded into your printer.

8 Click Print.

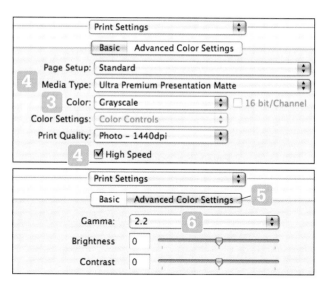

HOT TIP: Epson's print drivers have two black and white modes: Grayscale and Advanced Black and White mode. The Advanced mode is a way of colour-toning your black and white images, but it's better to do such toning in Photoshop.

SEE ALSO: For details on converting to black and white, see Chapter 10.

Use the History panel to undo flattening

Once a file becomes flattened, you can use the History panel to restore the layers in a file. The advantage of the History panel over the Undo command is that Undo only reverses the very last action that you took.

1 Make the History panel visible.

2 Click on one history state at a time until the layers are restored.

Here is an example where Undo will not restore the layers, because three actions have happened since the image was flattened. You can click directly on the event above to restore the layers.

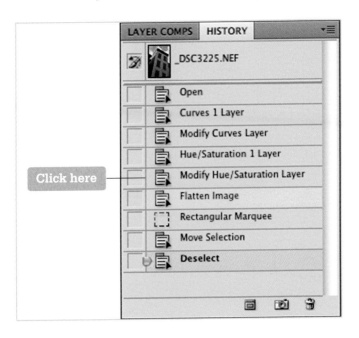

HOT TIP: Beyond explicitly using the Flatten command, layered files become flattened when you convert to a different colour space. Rather than clicking on one history state at a time, you can look for Flatten Image or Convert to Profile in the History panel and then click on the state immediately above it.

Top 10 Photoshop CS4 Problems Solved